# 50 FINDS
# FROM LANCASHIRE
## Objects from the Portable Antiquities Scheme

Stuart Noon

AMBERLEY

First published 2016

Amberley Publishing
The Hill, Stroud
Gloucestershire, GL5 4EP

www.amberley-books.com

Copyright © Stuart Noon, 2016

The right of Stuart Noon to be identified as the
Author of this work has been asserted in accordance
with the Copyrights, Designs and Patents Act 1988.

ISBN 978 1 4456 5837 7 (print)
ISBN 978 1 4456 5838 4 (ebook)

British Library Cataloguing in Publication Data.
A catalogue record for this book is available from
the British Library.

Typeset in 10pt on 13pt Celeste.
Typesetting by Amberley Publishing.
Printed in the UK.

# Contents

# Acknowledgements

I should like to thank all my colleagues in the Lancashire Museums Service for their support: in particular Dr Stephen Bull, the Military History and Archaeology Curator; Alex Whitlock; and Paul Hickman. Thank you to DigVentures, Matthew Hepworth, David Kierzek, Josh Starr and Gary Crace-Scholes for the excavation and photography of the Bronze Age hoards. I would also like to thank all the finders who have recorded their finds with the Portable Antiquities Scheme over the years, without whom this book would certainly not be possible.

# Foreword

The places in which we live and work have a long past, but one that is not always obvious in the landscape around us. This is a forgotten past. Most of us know little about the people who once lived in our communities fifty years ago, let alone 500, or even 5000 years past. Like us, they lived, played and worked here, in this place, but we know almost nothing of them ...

History books tell us about royalty, great lords and important churchmen, but most others are forgotten by time. The only evidence for many of these people is the objects that they left behind; sometimes buried on purpose, but more often lost by chance. Occasionally, through archaeological fieldwork, we can place these objects in a context that allows us to better understand the past, but nowadays excavation is mostly development led, so only takes place when a new building, road or service pipe, is being constructed.

A unique way of understanding the past is through the finds recorded through the Portable Antiquities Scheme of which those chosen here by Stuart Noon (Finds Liaison Officer for Lancashire & Cumbria) are just fifty of over 5,000 from Lancashire on its database (www.finds.org.uk). These finds are all discovered by the public, most by metal-detector users, searching in places archaeologists are unlikely to go or otherwise excavate. As such they provide important clues of underlying archaeology that (once recorded) help archaeologists understand our past – a past of the people, found by the people.

Some of these finds are truly magnificent, others less imposing. Yet, like pieces in a jigsaw puzzle they are often meaningless alone, but once placed together paint a picture. These finds therefore allow us to understand the story of people who once lived here, in Lancashire.

Dr Michael Lewis
Head of Portable Antiquities & Treasure
British Museum

# Introduction

The British Museum's Portable Antiquities Scheme (PAS) is a project funded by the Department of Culture, Media and Sport, encouraging the voluntary recording of archaeological objects found by members of the public in England and Wales. It does this through a network of Finds Liaison Officers, who are based in offices across England and Wales. Every year many thousands of objects are discovered, many of these by metal-detector users, people out walking, farmers or even gardeners.

Since 2004, PAS has been recording finds from Lancashire at the museum headquarters of the Lancashire Museums Service. These objects are often found in rural areas, where traditional archaeological excavation occurs less frequently. These objects tell us about the everyday life of people in the past, from the use of everyday objects to personal adornment. They inform us about what people made, the games they played, what they traded and how far these objects travelled.

The aim of this book is to highlight fifty finds from Lancashire and to reveal what stories finds can tell. The objects have all been reported to PAS and are recorded on the database www.finds.org.uk/database. The full record for each object can be accessed by searching under its unique reference number (usually starting with LANCUM-XXXXXX). Gaining permission from a landowner is essential in order to use a metal detector legally, field walk or excavate. Although many landowners are happy to grant permission, others are not. Therefore, the apparent absence of artefacts in an area do not necessarily indicate a lack of activity in the past; it may simply be to do with a lack of permission or inaccessibility.

Several of the fifty finds have been acquired by local museums through the 1996 Treasure Act. Treasure includes any metallic object, other than a coin, containing more than 10 percent precious metal (that is, gold or silver) that is more than 300 years old when discovered, and any group of two or more prehistoric base-metal objects from the same find. Also included as treasure are two or more coins over 300 years old that contain 10 percent gold or silver (if the coins contain less than 10 percent gold or silver there must be at least ten of them). Any object found in association with Treasure, such as a lead alloy or ceramic container, is also classed as Treasure. These items must be reported to the local coroner. The Treasure Act provides a tremendous opportunity for local museums to acquire new objects for their collections so that they can be enjoyed by the public.

Until recently Lancashire was regarded as something of an archaeological desert but the work of PAS, alongside recent community, commercial and research excavations, is challenging this assumption. Many areas of Lancashire have actually escaped aggressive agricultural and developmental practices, and therefore the survival of archaeological remains is high, making Lancashire an archaeologically rich area. There are significant gaps in the archaeological knowledge concerning particular areas, and current knowledge of the early periods is extremely limited; however, by looking at finds discovered in Lancashire and recorded by the PAS, we can discover more about this past.

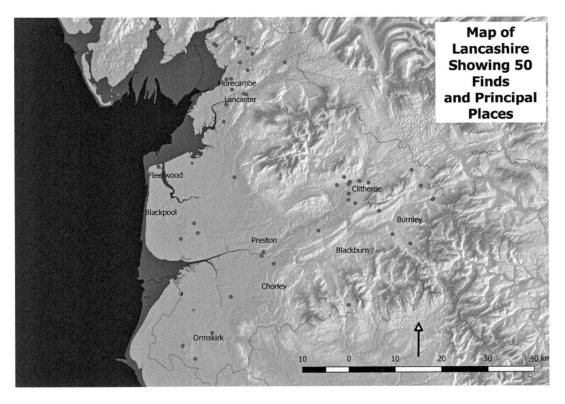

Contains OS data Crown copyrights [and PAS database right] (2016).

# Prehistory (500,000 BC–AD 42)

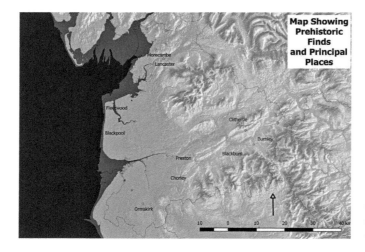

Contains OS data Crown copyrights [and PAS database right] (2016).

Lancashire has a long and diverse history. The evidence for the Palaeolithic is sparse in Britain, the last Ice Age having scoured the landscape. Most of the finds are from caves, but occasionally a tool does turn up in the landscape, such as the featured Clactonian knife or scraper.

Evidence for the Mesolithic period is much better represented and is traditionally biased to the uplands, where flint has been collected for over a hundred years as it erodes out of the peat. This has produced the greatest concentration of Mesolithic sites in the country. There is a large number of flints recorded on the database collected in the 1950s by the late John Winstanley that form part of a large collection of lithic implements and associated waste flakes.

Most of the recent evidence for the Bronze Age has come through the finds recorded with PAS, such as knives, razors, chisels and spears indicating Copper Age (Chalcolithic) mining and tool production. In the Copper Age, the 'Beaker' culture named after a type of distinctive pot is thought to have influenced the existing culture in Britain and brought about a number of changes in material culture and ritual belief. Metal was a new way of

showing off status, and brought the desire to own a copper object such as the featured knife blade. By the Bronze Age, it is believed that the Lancashire area was being intensively farmed, while burial mounds indicate occupation by a settled population. This is also indicated by the hoards recently discovered that relate to arrow deposition. These hoards have been the subject of archaeological investigation.

Objects recovered such as the chisel, dagger, sword, spearheads, axes and bracelets provide clues about the types of activity that occurred. Through examining these objects, we learn that many are not just functional but were also made to be aesthetically pleasing.

The Later Iron Age finds also reveal this juxtaposition between form and function; the attraction of an object is equally important to its purpose, as demonstrated in the purely northern phenomena of Dragonesque brooches.

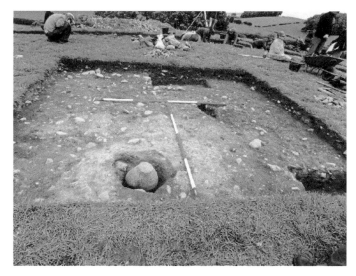

Find spot of a tanged chisel and knife-blade hoard.

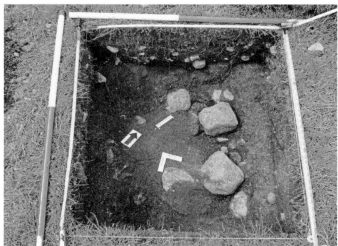

Hoard find spot for twenty-three assorted Late Bronze Age axes, spearheads, a chisel, arm and wrist rings.

# Chapter 1
# Paleolithic (4000–2351 BC)

This is a Clactonian flint tool with part of the cortex surviving near the edge; marks of secondary and tertiary flaking are clearly visible along the cutting edge. From the same field come a further five pieces of flint (flakes) and two pieces of ochre. The Clactonian industry involved striking thick, irregular flakes, which were then employed as choppers. The industry is named after a superb collection of Prehistoric material found on a site close to Clacton-on-Sea in Essex and at Swanscombe, near Dartford.

There are only three Clactonian tools currently on the database that were produced by the hominid species *Homo heidelbergensis.* Achulean and Clactonian traditions of flint knapping probably co-existed, with Achulean relating primarily to the production of hand axes.

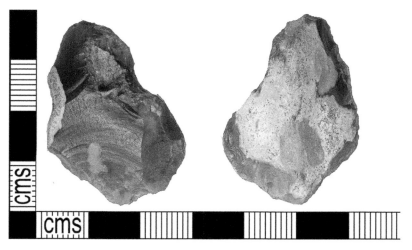

It is a tool made from the core, which is the parent material.

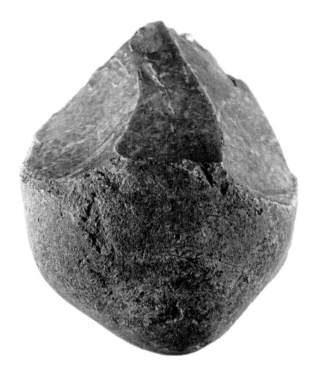

This flake is in the same Clactonian tradition as SUSS-E5D8F3.

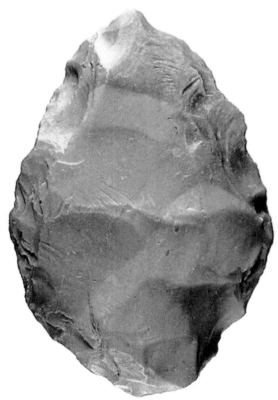

SUSS-64EE9A is a complete flint Acheulean hand axe.

# Chapter 2
# Mesolithic (2351–4000 BC)

A flint core that has a dark grey, glassy core, with a little creamy mottling and a small strip of cortex remaining.

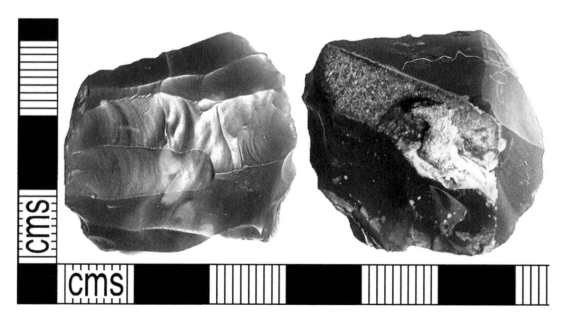

The core was used to make blades by pressure flaking.

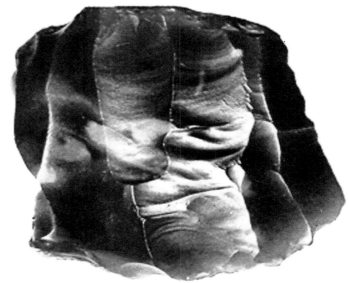

The flint has been worked by removing numerous elongated flakes called microliths.

These small blades (SWYOR-3BD924) are complete microliths consisting of tapered blades, blunted blades and ovate blades.

# Chapter 3
# Neolithic (4000–2351 BC)

**3. Lithic implement (LANCUM-DA9AF5)**
Neolithic (*c.* 2100–1600 BC)
Discovered in 2014 in Pendle.

This is an olive-grey, flint plano-convex knife, knapped on a secondary flake. The ventral (underside) is convex and the dorsal (upperside) is flat with a roughly central patch of retained cortex (outer layer). There is extensive retouching (repair) to both faces. There is a deliberate retention and emphasis of the differently coloured flint. The knife would have probably been hafted at the proximal end, and the retouching there (scaled, crossed semi-abrupt) supports this idea. Lancashire has no known natural sources of flint, but chert is a similar material used widely for tool manufacture.

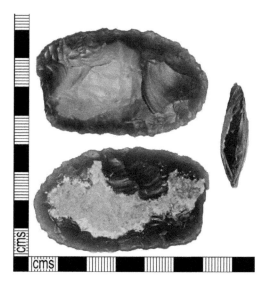

The term 'plano-convex' means plane on one side and convex on the other.

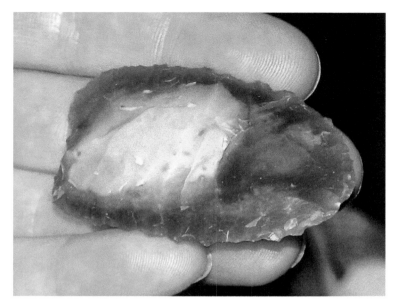

The lack of close parallels may be due to regional differences in lithic culture.

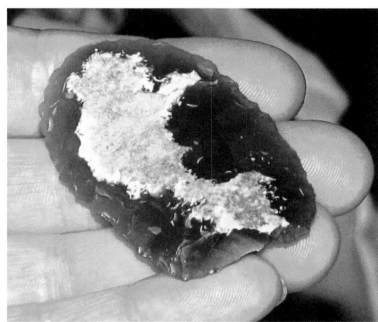

Flint occurs in chalk and chert in limestone; they are both from the remains of old seabeds and are formed from acid in rainwater reacting with fossils.

# Chapter 4
# Bronze Age (2350–901 BC)

**4. Lithic implement (LANCUM-B5D572)**
Bronze Age (*c.* 2,450–2,150 BC)
Discovered in 2013 in Sabden Fold.

This tool is made from black-banded Pennines chert. The surface reveals traces of weathering, but this would be consistent with the original working of the weathered face for extraction. The chert has been struck on three faces, and the proximal point has been worked into a long, narrow, broken tapering point, suggesting a kind of boring tool.

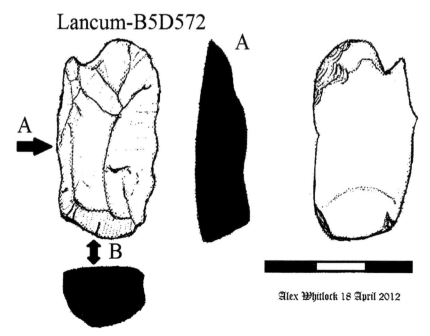

Lancum-B5D572

Alex Whitlock 18 April 2012

(Illustration by
A. Whitlock)

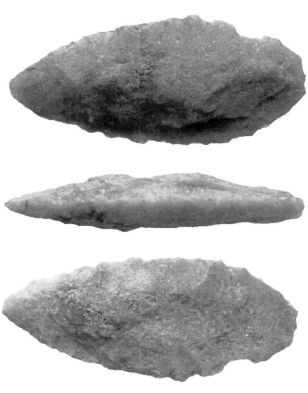

The minerals in the soil around the fossils dictate the colour; for example, SUR-F4D425 is made from a rose pink chert.

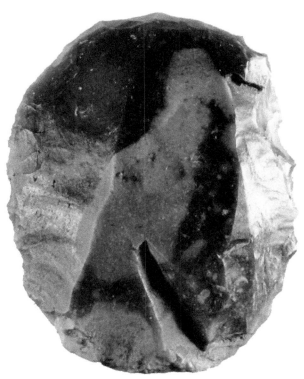

Similarly, SUSS-B71FCA is a grey chert scraper.

**5. Copper cakes (LANCUM-8CCE11)**
Chalcolithic/early Bronze Age (*c.* 2,450–2,150 BC)
Discovered in 2009 in Morecambe Bay.

Metal workers were probably itinerant, wandering workers, who buried cakes and traded for scrap items for use when they were in the area again.

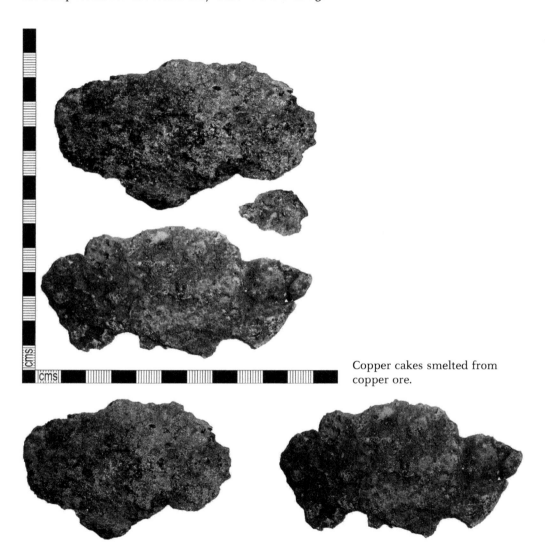

Copper cakes smelted from copper ore.

*Left*: This draws out the impurities.

*Right*: The cakes are then re-cast into objects.

## 6. Dagger (LANCUM-3BEC10)
Chalcolithic/early Bronze Age (c. 2,450–2,150 BC)
Discovered in 2009 in Morecambe Bay.

This is an extremely rare and important tanged copper dagger. The dagger is composed of a blade and hilt plate, and there is no obvious break at the end of the hilt plate. The hilt plate would have been of organic material, probably wood, horn or antler. The blade is roughly triangular-shaped and tapers towards the tip. The edges are bevelled and very thin, but there are no signs of wear and no re-sharpening marks.

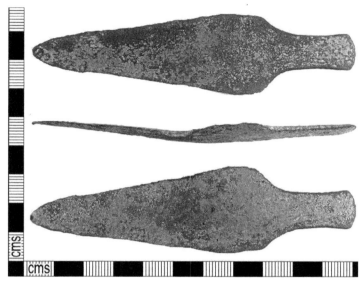

Most examples of copper daggers occur in early Beaker 'classic' grave assemblages associated with low-carinated beakers, wrist guards, arrowheads and jewellery.

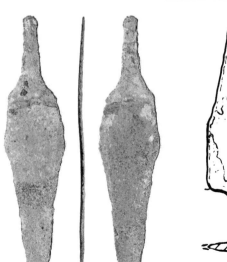

*Left*: The dagger is similar in form to DOR-FCCD7E.

*Right*: NMS-503645 belongs to the later Wessex culture or early Middle Bronze Age, according to notes taken from S. Gerloff (1975).

## 7. Hoard (LANCUM-A5AF1B)
Late Bronze Age (c. 1,000–800 BC)
Discovered in 2016 in Lancaster.

Hoard of twenty-three objects comprising spearheads, axes, a chisel, bracelets, wrist torcs and horse harness rings. The hoard was inserted into the edge of a burnt mound from an earlier period. A burnt mound consists of shattered stone and charcoal with a watertight trough. They are associated with cattle droving and used for a variety of purposes such as dying cloth, boiling meat and, I dare say, taking a bath.

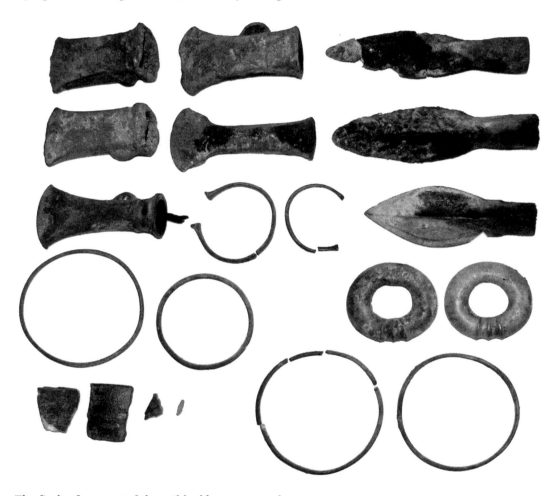

The finds after most of the soil had been removed.

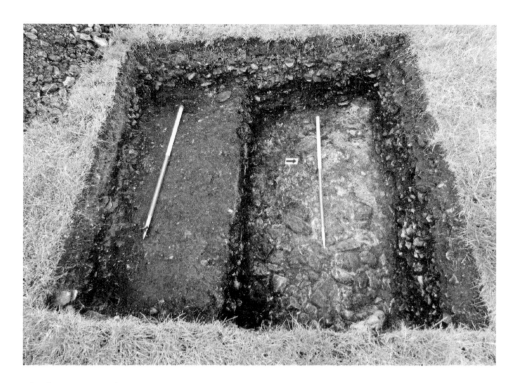

The burnt mound.

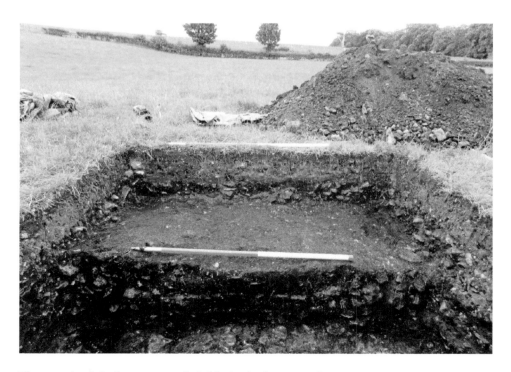

The trough of the burnt mound visible in the lower section.

## 8. Axe (LANCUM-874565)
Bronze Age (*c.* 2,250–1900 BC)
Discovered in 2012 in Pendle.

This copper axe is of a simple form, sub-rectangular in plan and section, gradually flaring to the blade end, with a narrow tapering sub-rounded relatively thin butt. There are no flanges on the axe, stop ridges, or evidence of any joints and it is probable that it was cast using a one-piece mould. This axe is characteristic of and appears to be a Class 2 relating to the Migdale metalworking tradition as defined by S. Needham et al (1985).

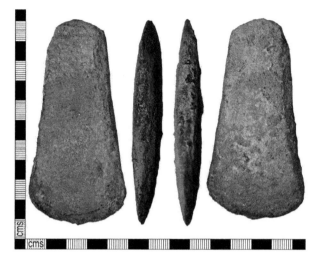

There is no evidence of any form of incised or cast decoration present on any surface of the axe.

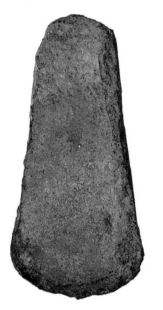
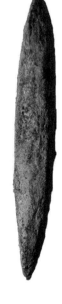

*Left*: The blade has a bevelled edge, probably resulting from hammering the edge.

*Right*: The sides of the axe gently expand in width from the butt to the blade.

## 9. Hoard (LANCUM-0788A0)
Bronze Age (*c.* 1,000-800 BC)
Discovered in 2013 at Bolton-le-Sands.

Often objects were inserted in existing monuments, such as the objects in a hoard discovered by detectorists that led to a site investigation in the form of an evaluation in 2013 by UCLAN university and then an excavation in 2016 by DigVentures and the University of Durham.

Copper-alloy, mid-to-late Bronze Age tanged chisel, dagger fragment, metal-working debris, ring and razor.

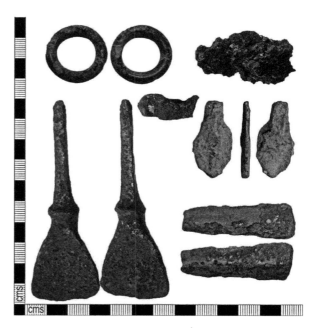

The hoard was inserted into a barrow.

Metal-working waste and copper-alloy rings are common in Bronze Age hoards and have been suggested as horse-harness fittings, handles of a sheet-metal cauldron of Class A1 or part of a chain from which a cauldron was suspended over a fire.

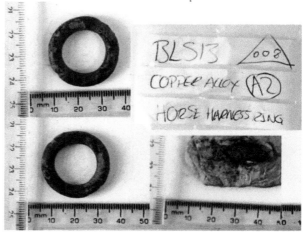

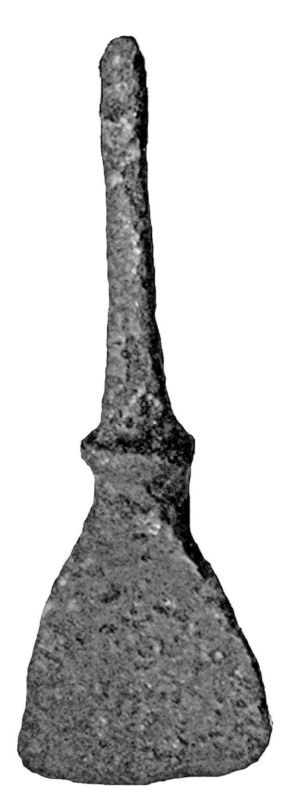

Tanged chisel, virtually complete and in good condition; it is tapering and square-sectioned with a wide oval collar separating the tang from the blade. Tanged chisels have been found in several Bronze Age hoards and have a wide distribution in Britain and Ireland.

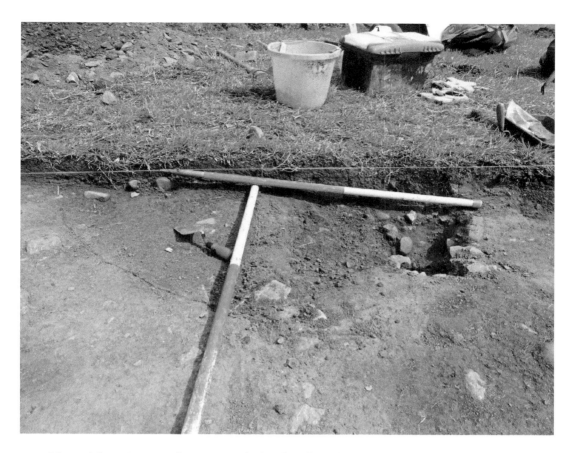

View of the UCLAN evaluation trench. (Paul Hickman)

A feature in the trench containing worked flint, chert, jet, daub, and cremated bone. (Paul Hickman)

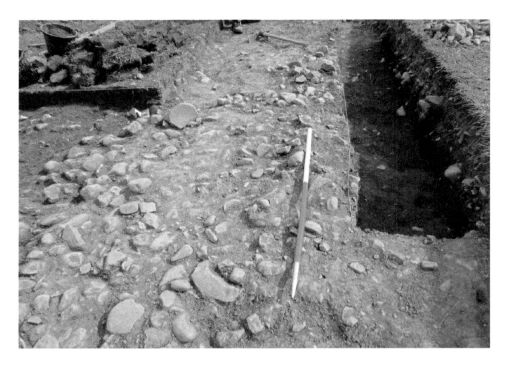

The trench revealed a stone kerbed bank.

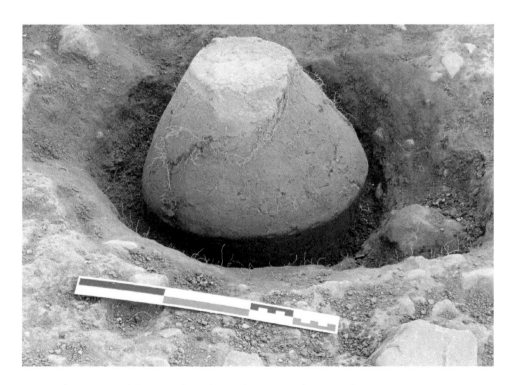

A complete inverted decorated food vessel was also discovered.

## 10. Spear (LVPL768)
Bronze Age (c. 1000–700 BC)
Discovered in 1997 in Priest Hutton.

This is a small and stumpy spearhead, with a kite-shaped blade. The blade and socket are undamaged and in good condition. The head of the spearhead is small, wide, and kite-shaped with clear re-sharpening marks all around the edges of the wings, running parallel to it. The casting seams along the sides are smooth.

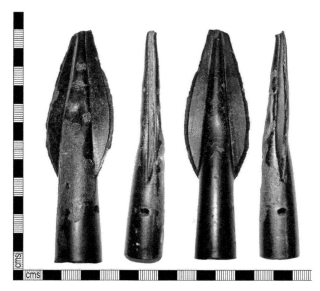

The spearhead is complete.

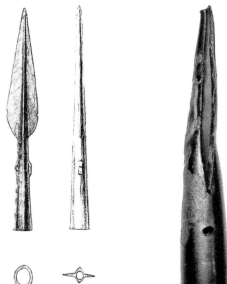

*Left*: This is a short version of a spearhead, often found in the north (NLM4608).

*Right*: An example of a large-sized spearhead is LVPL768.

This is a Late Bronze Age sword of the Wilburton (Wallington) Phase. The sword has wide, splayed V-shoulders with four rivet holes and the hilt slot in the tang, which retains a bronze rivet. The remainder of the blade is missing. The sword is an unusual find for Lancashire; C. B. Burgess notes that there is only one certain example of this form, from the Tees at Middlesbrough, recorded at Lancaster City Museum on 23 August 1999. Swords of the Wilburton tradition are more common in the south of England.

The sword is the perennial symbol of empires, knighthood, chivalry and fantasy. It is also one of the world's most ancient technologies, connected with breakthroughs in metallurgy that would change the world. There are even some types of ancient swords so strong that modern science still cannot determine how they were made.

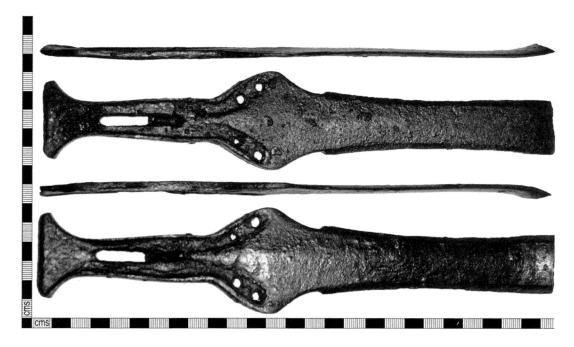

The sword has been deliberately snapped at about a third of its original length.

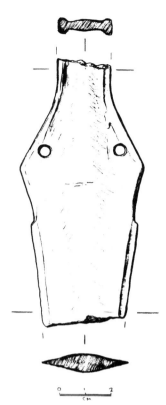

There are different traditions of sword making, such as this one from Kings Lynn. NMS-025B42 is a sword of 'Ewart Park' type.

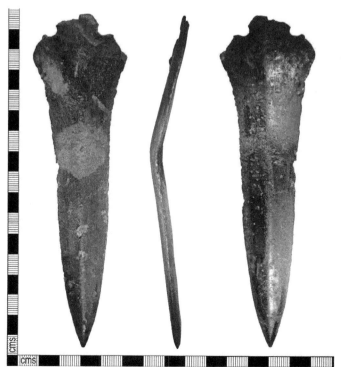

Short swords called 'dirks' were also a feature of the Late Bronze Age; this one is LIN-E5872D.

# Chapter 5
# Iron Age (800 BC–AD 42)

**12. Brooch (LANCUM-EC46C2)**
Iron Age (*c.* 25–65 AD)
Discovered in 2016 in North Turton.

A copper-alloy, complete Roman Aesica variant 'thistle', also known as a 'rosette'. Similar examples are illustrated in R. Hattatt (2000) and are dated to the 1st century AD. M. E. Snape comments that, 'Aesica type brooches were derived from continental thistle or rosette brooches, and their findspots are concentrated in the Midlands and central southern England'.

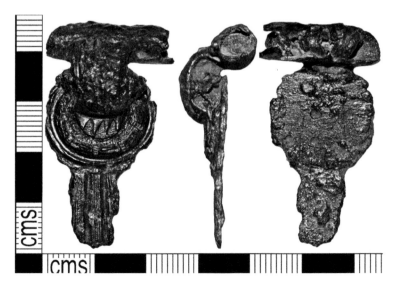

D. F. Macreth (1973) suggests they date to *c.* 60–80 AD.

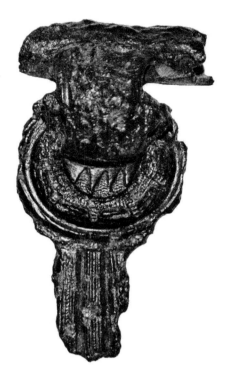

The brooch has a round, elegant plate in the centre with a Celtic-influenced repoussé style from which sprouts upwards a short, arched, fluted bow, curving backwards at the top to support tubular wings that contain the spring.

Below the plate is a wide, fantail-shaped fluted leg, now broken, at the rear of which would have been attached the catch plate.

A cast copper-alloy Dragonesque enamelled brooch with small 'cloisonné'-style fields. The fields on the obverse are of a geometrical and floral pattern, and are filled with different coloured enamel, probably red and blue. The head of the brooch is also decorated with enamel, especially around the circular 'eye'. They are normally double-headed but the lower head is missing, as is the pin, and the reverse is plain.

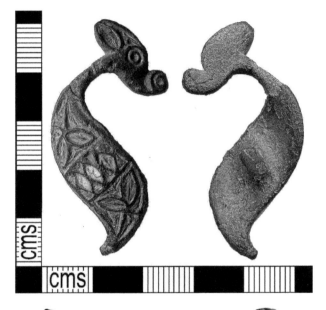

They only appear to have been made in the north of England, but examples are still found in the south.

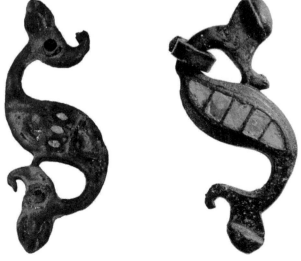

*Left*: A more complex version from Amesbury is LANCUM-B5C813.

*Right*: A more complete version from Doncaster is NLM-9C0F91.

# Chapter 6
# Roman (AD 43–409)

Roman activity within Lancashire is often not well attested but, in fact, there are significant densities of finds recorded over wide areas. There is a network of Roman roads and forts situated at Lancaster, Ribchester and Kirkham, with a probable supply depot at Walton-le-Dale in Preston.

Ribchester Roman Fort *Bremetannacum Veteraniram* was in use throughout the Roman period and became a veteran's settlement for the Sarmatian cavalry.

There are a number of Roman features on Worsthorne Moor, with significant coin hoard densities around Burnley, Colne and Whalley. Copper-alloy objects were often tinned or silvered to make them look more precious. Tinning simply requires the object to be dipped in molten tin, while silvering was achieved by beating out silver foil and attaching it to the object with lead/tin solder. From the second century AD onwards, enamel inlay became popular.

The Roman finds in Lancashire reveal aspects of domestic life from a cosmetic pestle used for make-up to lamps to a furniture mount, unique brooches and the handle of a *patera* (pan) from the first Ala of Thracians.

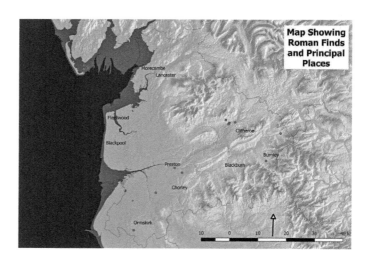

Contains OS data Crown copyrights [and PAS database] (2016).

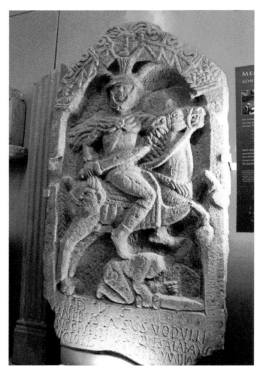

*Left*: Roman cavalry tombstone in Lancaster City Museum depicting a 'Curator' – a quarter master or junior officer – of the *Ala Augusta*, riding with the severed head of a barbarian enemy in his hand.

*Below*: Ribchester Roman Museum. (David Dunford)

*Above*: Remains of a pair of Roman granaries at Ribchester. (Immanuel Giel)

*Right*: Column at Ribchester. (Immanuel Giel)

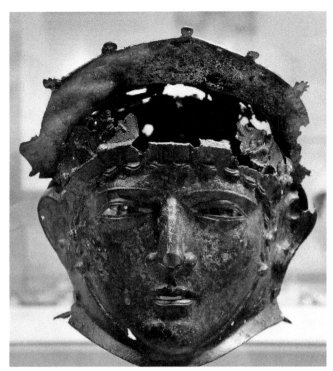

*Left*: The fabulous Ribchester Roman helmet, discovered in 1796, would have been tinned or silvered. (Carole Raddato)

*Below*: Detail on the helmet. (Johnbod)

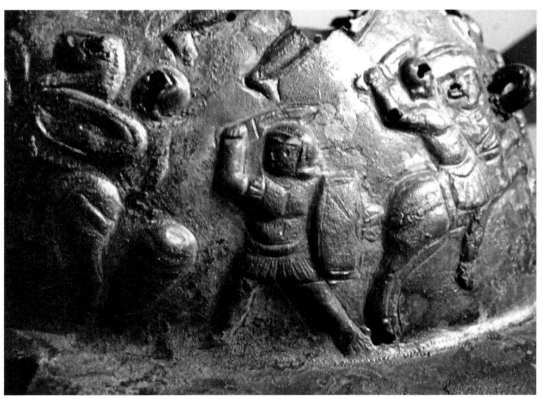

## 14. Cosmetic Pestle (LANCUM-939CF4)
Roman (*c.* 1–200 AD)
Discovered in 2013 in Bolton-le-Sands.

A fragmentary cast copper-alloy, two-piece cosmetic grinder mortar pestle set. The grinder retains one cast ring on one side, with a thin moulded collar separating it from the remains of the blade. The extremely worn blade strongly tapers away from the ring.

*Right*: R. Jackson (1985, p. 1) comments that 'cosmetic mortars and pestles are a British phenomenon, and can be dated to the late Iron Age to early Roman periods, *c.* 100 BC–300 AD'.

*Below left*: Mortars varied in form, one example being WMID-0625CE.

*Below right*: Mortars like SF-983ADC were used to grind small quantities of powder and probably had an association with fertility, some having male and female animal head terminals.

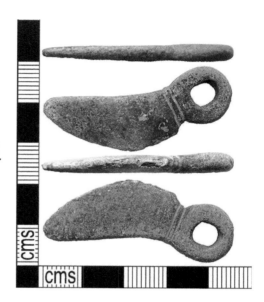

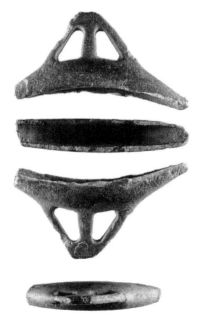

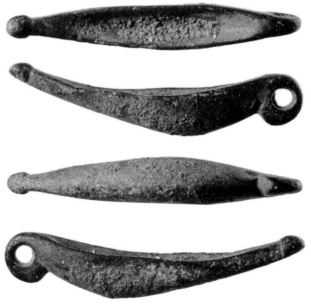

Fragment of a cast copper-alloy handle from a Roman skillet or *patera*. The *patera* is decorated with two deep grooves that run parallel to the outside of the handle and two circular moulded bands or ropes around the circular hole in the centre of the terminal and along the outside of the terminal. The handle is stamped on the obverse, reading '*ALA.VM.A* [...]', linking the pan to the Roman 'fifth ala'.

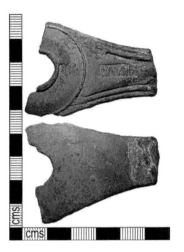 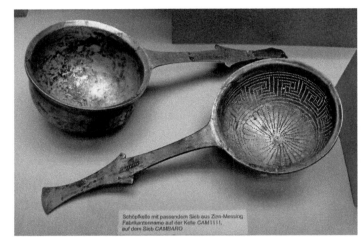

*Pateras* are saucepans.

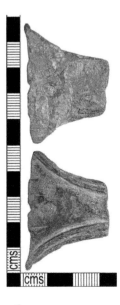

LANCUM-8D8AC3 is another fragment found at the same time by a different finder; they were originally recorded as two different finds.

A cast copper-alloy Romano British spouted laver (large basin) mount or escutcheon, which is zoomorphic (animalistic). The attachment is through the mouth of the laver, while a groove separates the face from the hair, which is also defined by a series of grooves. Below the hair, the sides curve outwards towards the chin, which is bearded and again defined by a series of grooves. The nose is wedge shaped, pointing out in relief, while the eyes are narrow. The face has fairly prominent cheekbones.

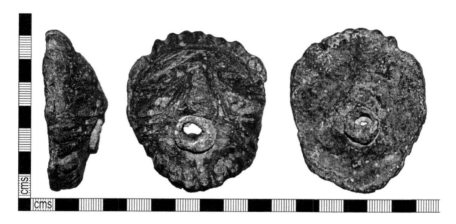

The mouth is not clear, but appears to be quite small.

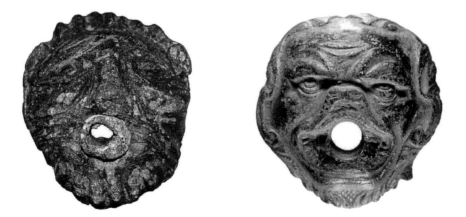

*Left*: The mount is cast in relief to form a lion head on the front convex surface; the reverse is roughcast and is concave, with the facial features depicted by incised lines.

*Right*: The laver is similar to WMID-178D25.

A copper-alloy furniture mount fitting depicting a bust of the Roman goddess Diana. The front of the mount shows moulded features such as Diana's face, dress, hair and part of her quiver; the reverse is flat and slightly hollow, showing remains of solder in the hollow of the reverse.

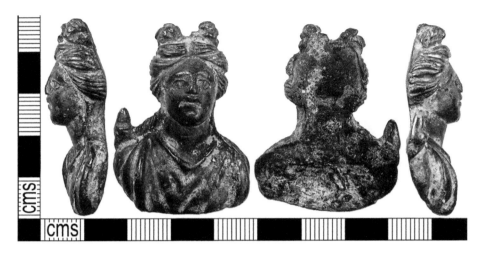

Diana combined the functions of a woodland and fertility goddess, mostly represented in her capacity of a goddess of hunting.

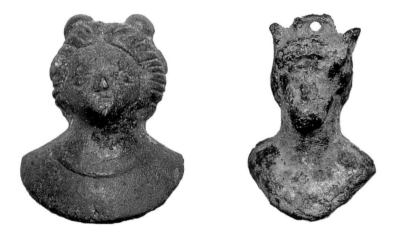

*Left*: This mount is similar to ESS-D51C31, which is also from a casket or item of furniture.

*Right*: The image of Diana was used on a range of objects, such as this steelyard weight NCL-CF6F62.

## 18. Vessel (LANCUM-361F75)
Roman (*c.* 50–250 AD)
Discovered in 2003 in Lancaster.

Three fragments of a copper-alloy enamelled vessel in shape of a cockerel. S. Worrell (2012, 83–84) states that 'there are only a few such vessels from the North West provinces (such as Britain) from workshops producing enamelled bronzes in the Rhineland and Belgium'.

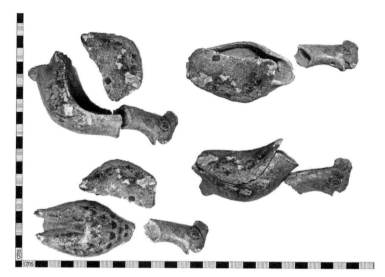

The vessel may have been a container for jewellery or smaller items of value.

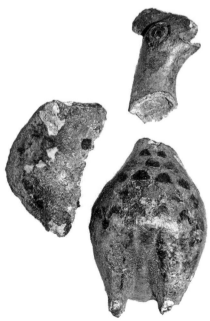

The first fragment is the lower part of the body, which was used as a container.

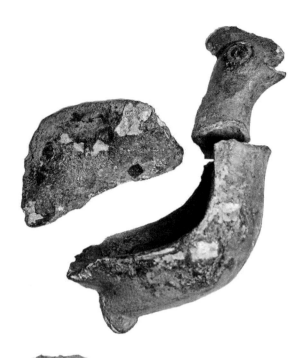

The second is a large fragment of the upper body (wing), used as a lid, and the neck and head; these are hollow cast but filled with clay. The legs and feet are missing.

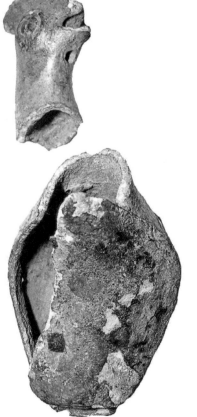

The eyes and possibly also the beak are decorated with red and black enamel, and both body and wing have a pattern of enamelled patches (blue, black and red) in the shape of stylised feathers.

**19. Hoard (LANCUM-C7EF68)**
Roman (*c.* 69–161 AD)
Kelbrook.

The hoard of silver *denarii* comprises Vitellius, AD 69; Domitian, AD 90–92; Vespasian, AD 75; Diva Faustina I, AD 141–161; Domitian, AD 81–96; Vitellius, AD 69; Trajan, AD 114–117; and Trajan, AD 98–99.

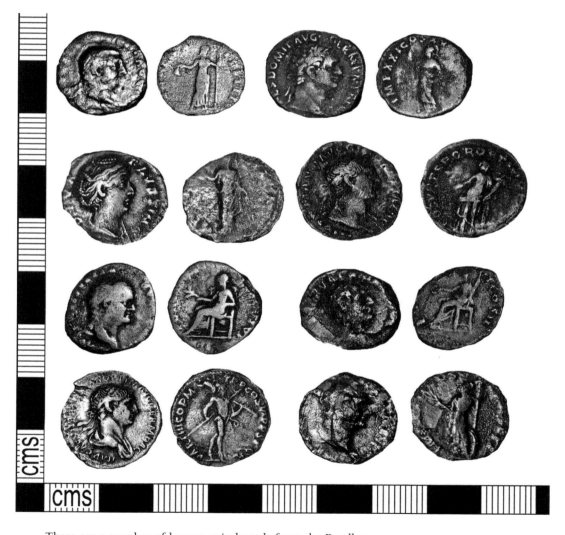

There are a number of known coin hoards from the Pendle area.

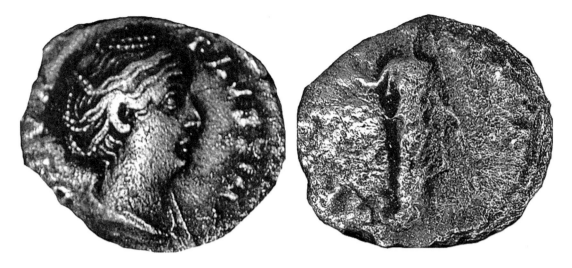

Faustina I was an empress and wife of Antoninius Pius.

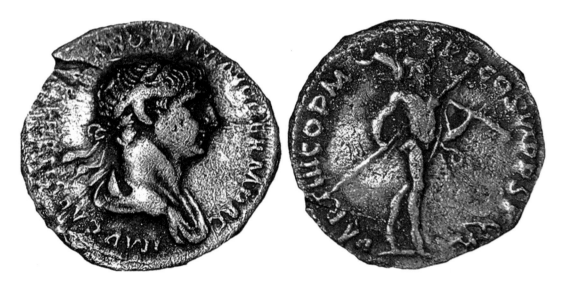

The best-preserved coin is the *denarius* of Trajan.

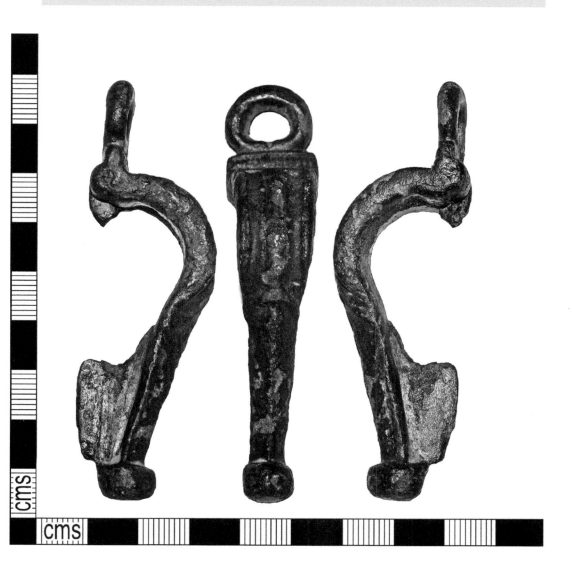

Brass brooches of the Headstud variety. The robustness is suggestive of the Castleford variants but does not match exactly any of the known Castleford types as categorized by H. E. M. Cool. There are no wings and at the top of the bows are huge integrally cast loops. There is a headstud at the apex of the bow, which is integrally cast and decorated with a moulded circular stud at the top of the bow. A square-sectioned bow is comma-shaped in profile and 'D'-shaped in cross section. It extends centrally from the front of the bow, tapering steadily in width to a double-banded, circular foot knop. There are transverse lines running the length of the bow.

The brooches share similarities, apart from the wings, with D. F. Mackreth-type Headstud R1 (East Midlands regional variant) and Thelby-type brooches depicted by R. Hattatt.

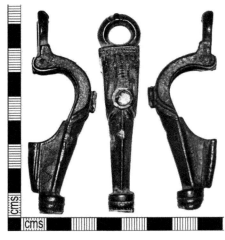

It is possible that the brooches are an unknown Castleford variant or a new Lancashire type.

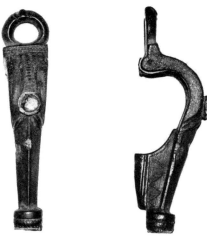

*Left*: Closer detail of one of the brooches, showing the reverse.

*Right*: The side of the brooch is also decorated with zig-zag lines, probably 'Celtic'.

**22. Spear (LANCUM-1E88EA)**
Roman (*c.* 200–600 AD)
Discovered in 2016 in Clitheroe.

A complete copper-alloy 'Door Knob Spear Butt'. The butt comprises a hollow shaft, tapering slightly from the open end before expanding where it joins the door-knob terminal. The terminal is bulbous and hollow, with a rounded base.

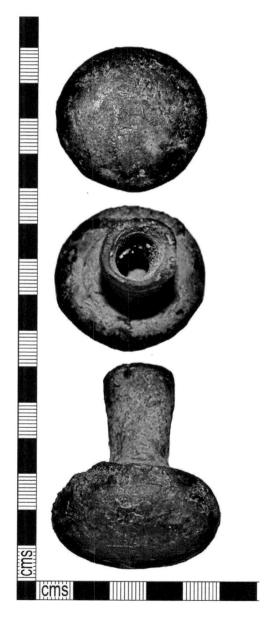

The metal is pitted and mottled with a mid-brownish patina.

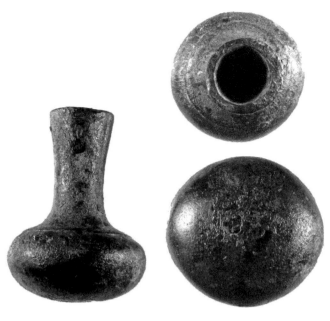

A similar example is
YORYM-EFBB77.

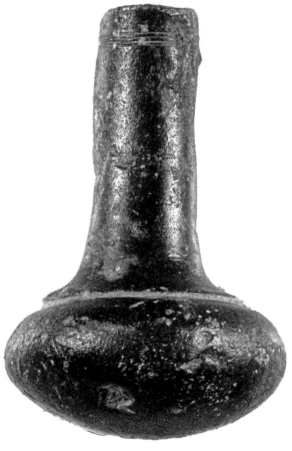

A longer example is YORYM-35C9E7.

# Chapter 7
# Early Medieval (AD 410–1066)

Very early medieval objects were not thought to be common in Lancashire but that is beginning to change.

The Silverdale Hoard is the third largest in Britain, and many of the items present strong similarities to the Cuerdale Hoard; both are broadly contemporary *c*. 905 AD. These hoards help us build a picture of Viking activity, providing insight into the appropriation and re-use of objects and coins in the Viking period.

Other early-medieval objects have also been discovered, including fourteen Saxon pennies, a brooch, mount and a sword pommel that dates from the tenth century to eleventh centuries when the River Lune near Lancaster may well have been the *de facto* border with Scotland, as indicated by the large number of mottes aligned along it. A swivel mount attests to the activity of the Normans around Clitheroe Castle.

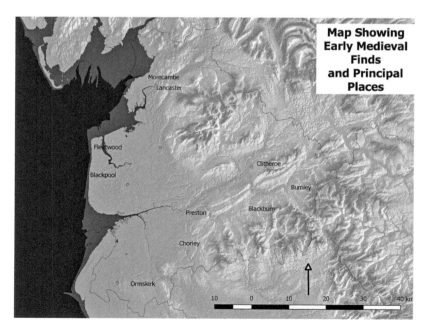

**Map Showing Early Medieval Finds and Principal Places**

Contains OS data Crown copyrights [and PAS database right] (2016).

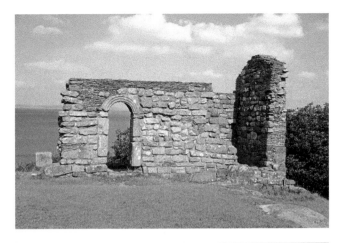

St Patrick's chapel on Heysham Head is an Early Medieval building, dating back to the sixth or seventh century. (Antiquary)

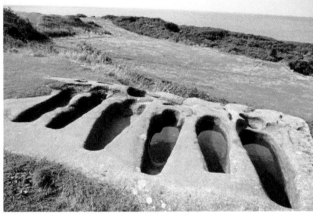

The chapel has rock-cut tombs hewn into the cliff. (Antiquary)

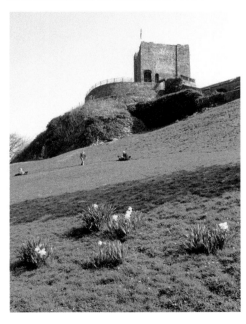

It is thought that there was a castle at Clitheroe as early as 1102. (Immanuel Giel)

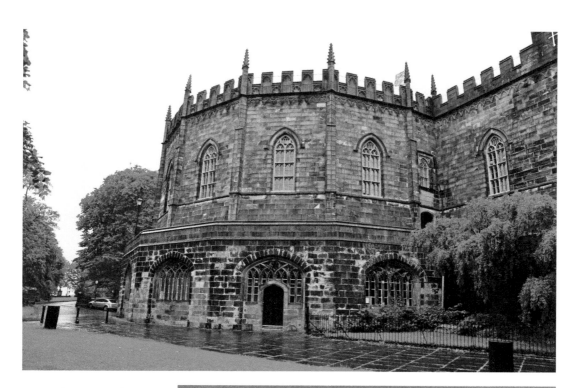

*Above*: It is thought that Lancaster Castle may date back to the eleventh century; it overlooks a crossing of the River Lune. (Nilfanion)

*Right*: Hoards represent incursions by the Vikings in the nineth and tenth centuries. (BabelStone)

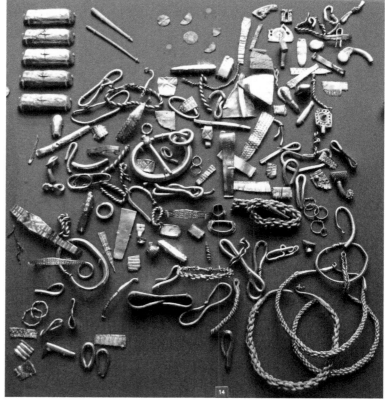

51

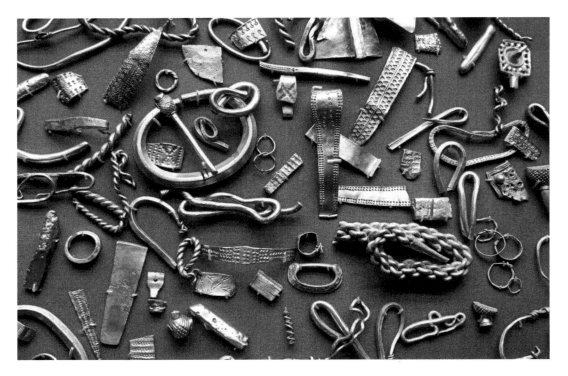

The Cuerdale Hoard, discovered in 1840, is the largest silver Viking hoard ever found in North West Europe. (Jorge Royan)

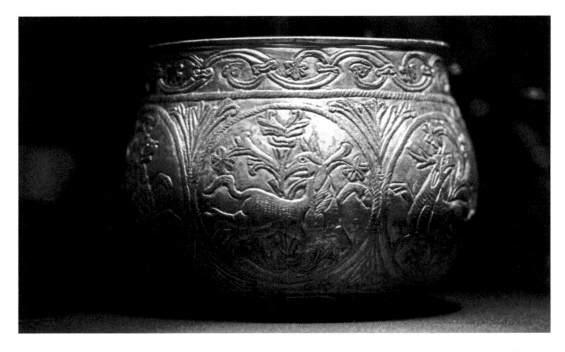

The Vale of York Hoard is the second-largest Viking Hoard. This hoard was in a silver-gilt 'bowl'.

## 23. Brooch (LANCUM- D103A2)
Early Medieval (*c.* 400–600 AD)
Discovered in 2010 in Garstang.

An almost complete copper-alloy, small, early Anglo-Saxon brooch. The brooch pin is missing and the head plate is rectangular in shape, with an integral semi-circular shaped top knob. The front face of the head plate is decorated with a pair of parallel border grooves, and a pair of transverse grooves can also be seen at the base of the integral top knob.

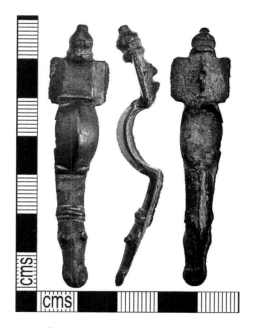

The bow is faceted; it has two transverse grooves at either end and central, raised longitudinal groove running down its front face.

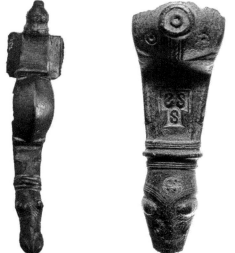

*Left*: The foot ends with an angular zoomorphic head, possibly a representation of a horse or dragon.

*Right*: This is a rare find for Lancashire as they are more usually found in the south and east of the country, such as this example from Suffolk SF-EC7654.

### 24. Hoard (LANCUM-65C1B4)
Early Medieval (*c.* 900–910 AD)
Discovered in 2011 in Silverdale.

The Silverdale Hoard comprises silver arm-rings, coins, and ingots with chopped-up pieces of silver known as 'hacksilver'. All of the finds, except one coin, were within a lead container at a depth of about 18 inches, with five of the larger, complete arm-rings underneath. The hoard reveals the truly international nature of Viking society – with coins minted in current-day Baghdad (Iraq) and the Frankish Kingdom (France). It shows the skilled artisanship and – potentially – brings to us the name of an unknown king of Northumbria (*Harthacnut*) through one small, but significant, coin.

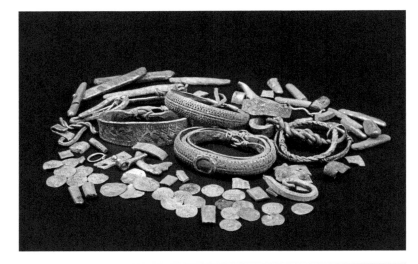

The Silverdale Hoard.

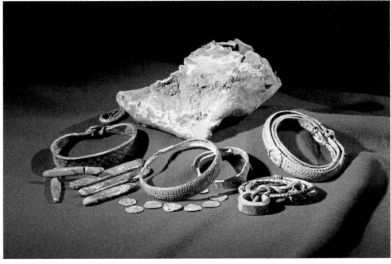

The survival of this lead container is, in itself, a rare occurrence that adds significance to the find.

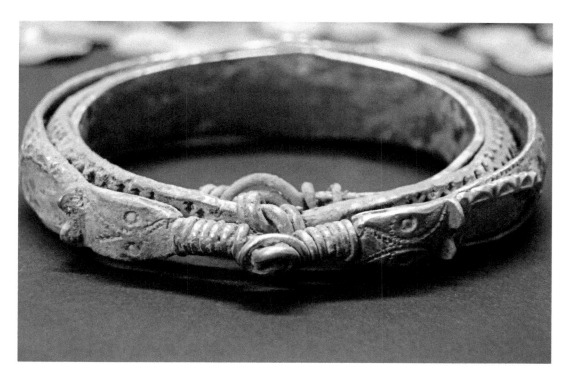

Carolingian reliquary, re-used as a Viking arm-ring.

This mount is a silver sheet disc, riveted to a bronze base-plate with a sub-triangular projection at each quadrant. The disc divides into four decorated fields by a plain cruciform frame, expanding at the ends of the arms into arcs joining a plain border.

It is decorated in the mainly ninth-century Late Saxon Trewhiddle style, with the tail crossing the body and distinctive double nicks on neck and body, with the animals arranged in two opposed pairs.

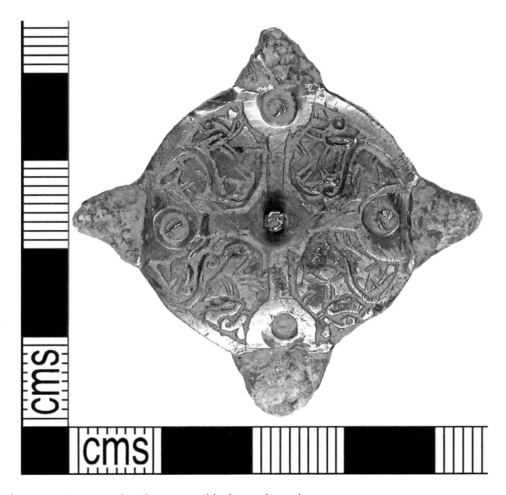

The mount is a strap-distributor, possibly from a horse harness.

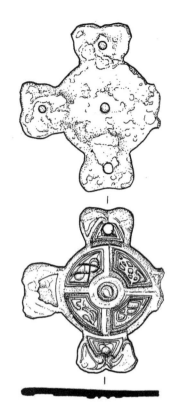

This is an extremely rare find for Lancashire, as they are more common in the south of England. One example from further south is this mount, WAW-2FBFF8.

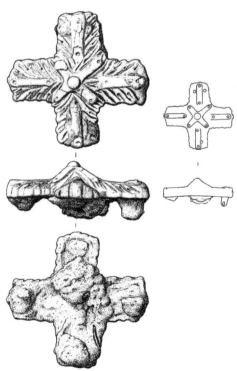

Another cruciform mount from this period is from Norfolk – NMS-56CC31.

This is a copper-alloy sword pommel of late lobed form. The base, which curves upwards at the ends, would have rested upon a concave pommel bar. The interior of the pommel has an oval opening at the base and converging sides towards the oval aperture at the apex of the pommel, which accommodated the protruding sword tang. H. R. Davidson (1962) considers this form to be of English origin, but R. E. Oakeshott suggests it is 'of late Viking style' (1991). This one is a Petersen L-type VI pommel, categorised by J. Peterson in 1919, a fusion of Anglo-Scandinavian and Anglo-Saxon fashions.

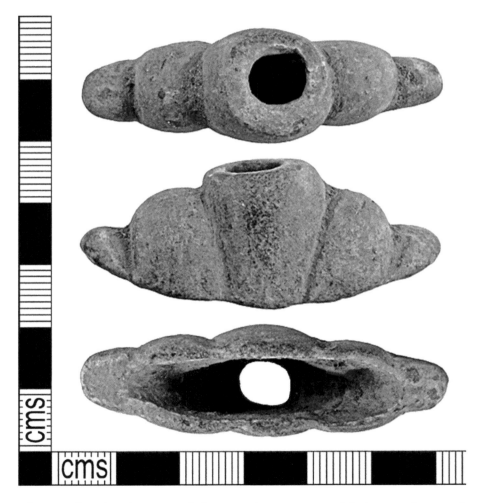

H. Geake considers that this mount belongs to the same type of fitting as a lozenge-shaped mount from Bawburgh, Norfolk.

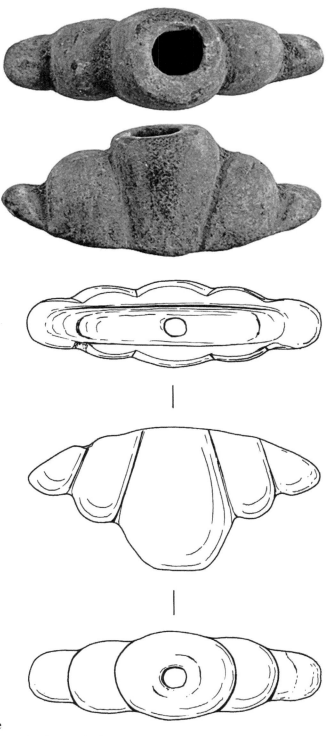

The perforation at the top of the object is slightly off centre. The exterior is decorated with a central lobe and flanked on each side with smaller lobes and long terminal knops.

Numerous similar examples have been recorded on the database, such as SF7529.

Another rare find for Lancashire consists of a hoard of Anglo-Saxon silver pennies, all of a single type – the CRVX type of Æthelræd II, king of England (978–1016). There are three complete coins, substantial fragments of two more and smaller fragments of a further two.

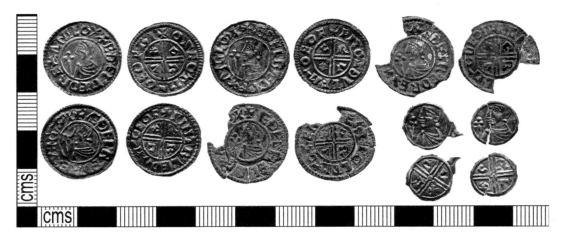

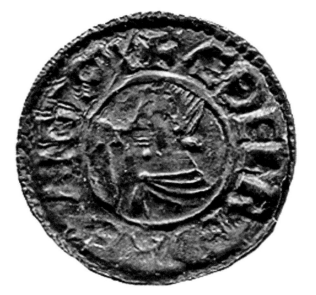

*Above*: They were all issued in the 990s.

*Left*: The coins were found in close proximity.

These are copper-alloy, swivel-mount rings. Each loop formed as a pair of opposed zoomorphic heads. The swivel comprises two hemispherical sections, one with a pin and the other pierced. The pin is inserted through the piercing and flattened over to trap it; there are transverse bands on the lower parts of the swivel halves. These mounts strengthened the point where a leather strap had to turn freely through a wide arc.

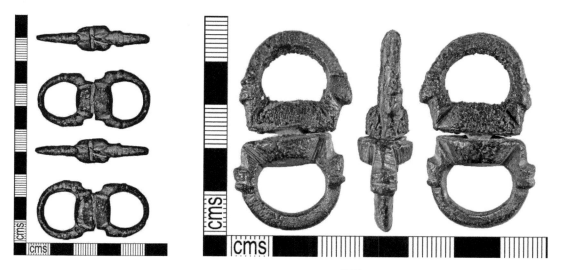

*Above left*: The mount is complete and still articulated.

*Above right*: Another similar mount from Bishop Middleham in County Durham is DUR-6AEB8E.

*Right*: Swivel mechanisms such as KENT-EEAFD0 were employed for a variety of functions during the medieval period – for example, strap fittings. Consequently, a specific function cannot be attributed to them.

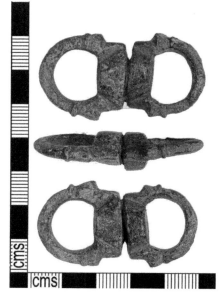

# Chapter 8
# Medieval (AD 1066–1539)

Information from metal detecting and other investigations is improving the knowledge of the medieval period in Lancashire, which is under-represented in the archaeological record. Many objects have a religious connotation and can be linked to the rise of the church, such as the crucifix.

Ampullas and badges are evidence of pilgrimages. They were designed to contain a dose of the holy water dispensed to pilgrims at many shrines and holy wells. Thanks to returning pilgrims, they probably featured as secondary relics in virtually every thirteenth-century English parish church.

An ear scoop and cooking pan reveal details of everyday life, while rings give us details of personal adornment. In a time of widespread illiteracy, seals for signing documents became reasonably commonplace. Important ecclesiastical figures, women, merchants and aristocrats used seals.

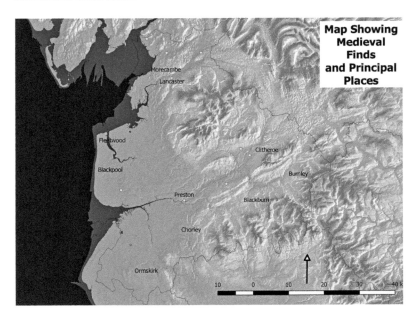

**Map Showing Medieval Finds and Principal Places**

Contains OS data Crown copyrights [and PAS database right] (2016).

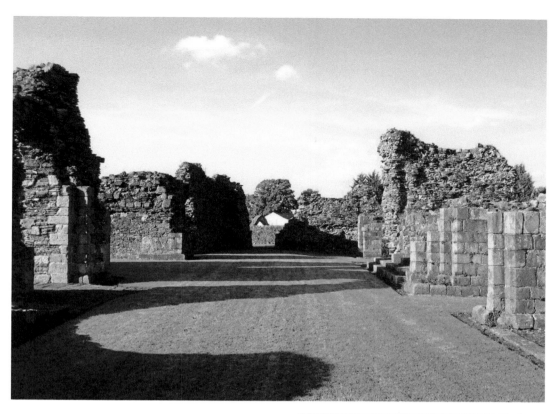

*Above*: Sawley Abbey, a twelfth-century Cistercian monastery. (Tony Grist)

*Right*: Thirteenth-century Whalley Abbey grew to become the second most powerful abbey in Lancashire. (Craigthornber)

## 29. Finger ring (LANCUM-469077)
Medieval (*c.* 1400–1550 AD)
Discovered in 2005 in Kirkham.

A gold finger ring with a slightly concave surface between two bands that enclose an inscription in French, which reads, '*A MA VIE*' (To my life). Rings with inscriptions carrying romantic sentiments were sometimes exchanged as wedding, betrothal or eternity rings in the Middle Ages. The beginning of the inscription is identified by a six-pointed star.

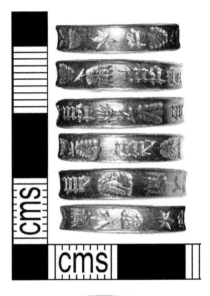

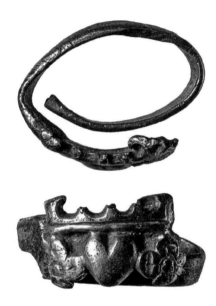

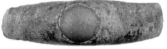

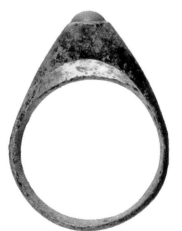

*Above left*: The words of the inscription are separated by engravings of flowers and punched decoration resembling bunches of grapes.

*Above right*: Rings were also made in silver like this Cladagh ring from Buckinghamshire, BH-05F4B1, which represents love, loyalty, and friendship.

*Left*: Copper-alloy rings were made for people who were not aristocratic, and would have been gilded or silvered to give an appearance of affluence. This is a 'stirrup'-shaped finger ring (WILT-7C366D), suggested by Egan and Pritchard (1991) to be popular from the mid-twelfth to the mid-fifteenth century.

Medieval lead ampulla, probably from Canterbury.

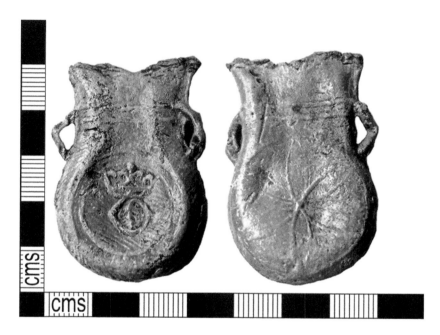

They were filled with holy water and, upon returning home, were poured out on the land to bless it.

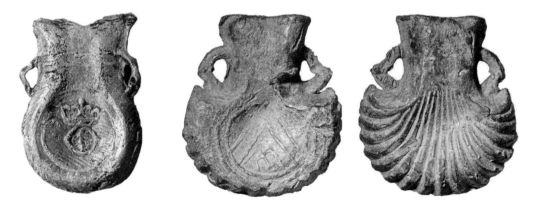

*Left*: The crown decoration is emblazoned with a lombardic 'T' for Thomas Becket.

*Right*: *Ampullae* were produced in a variety of styles, as exemplified by LIN-C5FADF.

## 31. Pilgrims Badge (LANCUM-371FC5)
Medieval (*c.* 1400–1600 AD)
Discovered in 2014 in Qernmore.

Badges were brought back as evidence of a completed pilgrimage. The metal that it was made from reflected the status of the purchaser.

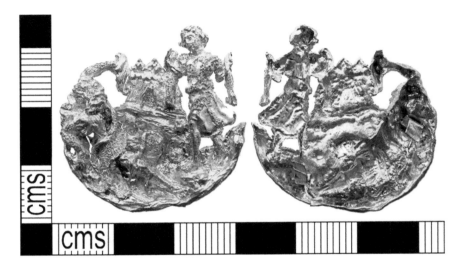

This badge in gold depicts David and Goliath, and was probably a hat ornament.

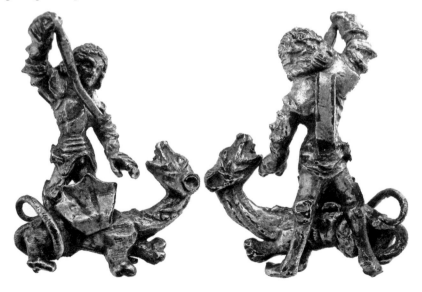

A variety of notable figures were depicted on pilgrim's badges such as this George and the Dragon in silver gilt from Cumbria, LANCUM-4501B2.

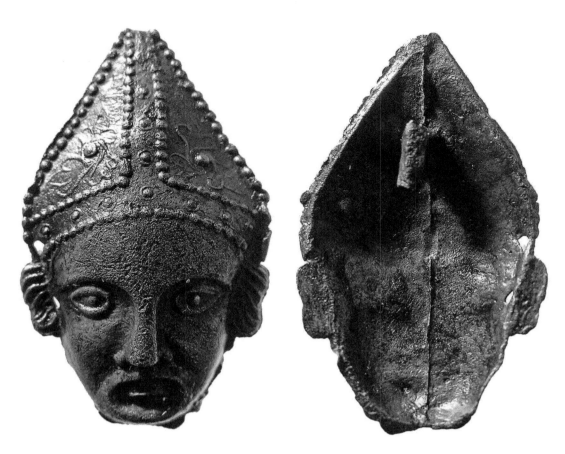

Badges were more commonly made out of lead and tin alloys such as this St Thomas à Becket badge (LON-0801CB), which was a popular depiction for pilgrim's badges.

This is a gold quarter noble of Edward III.

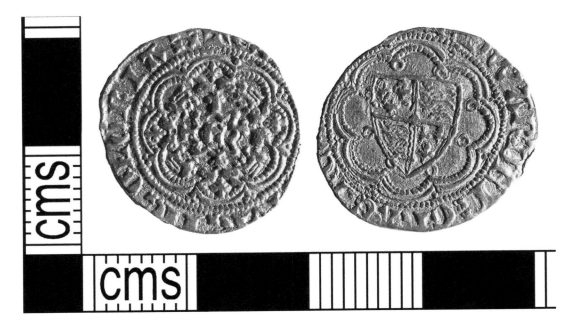

It is from the Transitional Series of the Treaty of Bretigny period before the title to the kingdom of France was returned to the French.

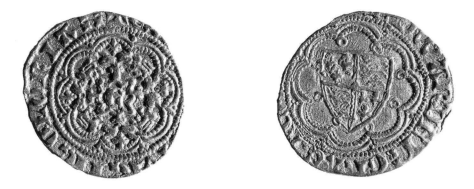

*Left*: Cross potent; saltire stops, annulets on cusps of obverse tressure; large 'E' in centre of reverse (North 1224(i)).

*Right*: Gold coins are rare finds in Lancashire and this is in extremely fine condition.

This lead vesica-shaped (pointed oval) seal matrix depicts a trident-shaped fleur-de-lis with an inverted legend in relation to the suspension loop. Females' matrices are generally far less common than those of males. The back is plain other than the intact suspension loop towards the middle bottom.

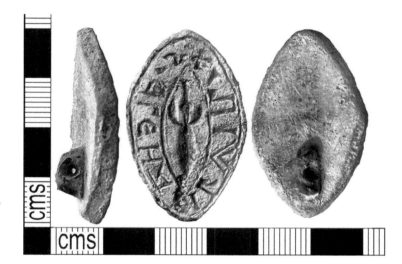

Inscription:
*S[IGILLUM]' ELENA FIL[IAE]' WILL[HELMI]* (Latin: The seal of Elena (Helena), daughter of William).

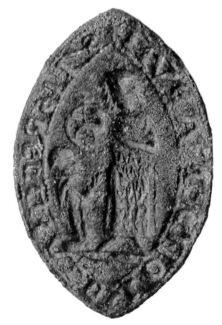

Many seals are also religious, such as BERK-06C29F. This was probably the seal of Reginald the seventh, prior of Bicester Priory, who held the position from AD 1261 to AD 1269 when he resigned, as detailed in *VCH Oxfordshire* (Volume 2; 1907:95).

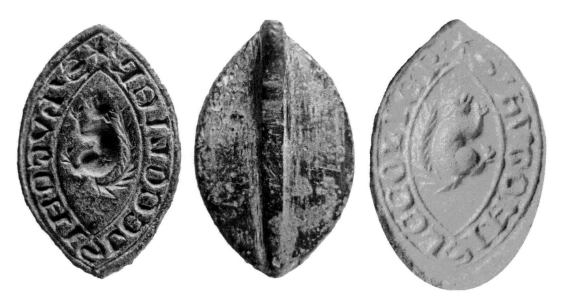

This one was made for Hugo the student, HAMP-0C98EC.

## 34. Crucifix (LANCUM-E0C267)
Medieval (c. 1400–1550 AD)
Discovered in 2014 in Bashall Eaves.

A silver crucifix pendant showing Christ, crucified on a cross with the Virgin Mary to his right and St John the Evangelist to his left, with incised decoration on the foliate terminals and on the halo behind Christ's head. The terminals of the cross are three-part foliate tendrils with sprouting leaves. The fourth terminal above Christ's halo has broken. The reverse of the pendant is plain.

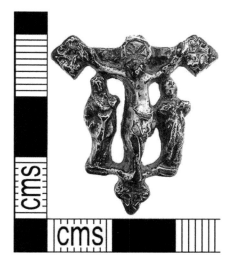

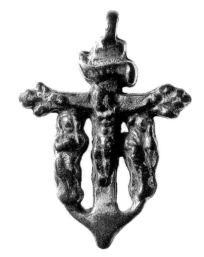

*Above left*: The Virgin and St John stand on a small ledge above the base terminal.

*Above right*: A silver similar pendant in the form of the Holy Rood is SWYOR-4CFE88.

*Right*: On this pendant from Tewkesbury, GLO-75E0F0, there is a silver ring held within the loop where a chain would have been inserted in order to allow the pendant to be worn around the neck.

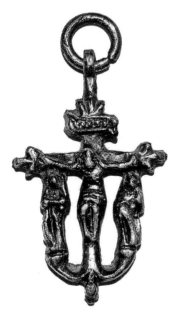

## 35. Cosmetic Spoon (LANCUM-3B6935)
Medieval (*c.* 1300–1400 AD)
Discovered in 2015 in Melling with Wrayton.

This bent, shaped and hammered silver sheet toilet implement consists of a combined ear scoop and toothpick/nail cleaner. The terminal is flat and sub-triangular in shape, with the sides tapering sharply towards the tip. The pointed tip of the terminal is missing. The shaft has simple S-twisted decoration, comprising of three twists.

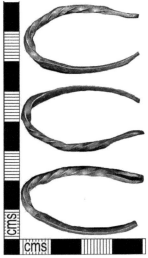

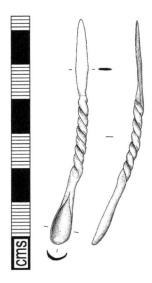

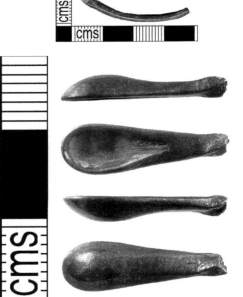

*Above left*: This part of the shaft has a line incised along the centre of each face, making it look as if there are twice as many twists.

*Above right*: Cosmetic implements such as this ear scoop from the Isle of Wight, IOW-228C18, date from the Roman period onwards. It is the twisted handle that suggests it is later in date.

*Right*: There are a number of similar silver scoops on the database, such as HAMP-4806FC.

## 36. Purse Bar (LANCUM-2A56E4)
Medieval (*c.* 1475–1520 AD)
Discovered in 2013 in Clitheroe.

A fragment of cast copper-alloy purse-bar frame. This fragment represents the central boss of the purse bar and one of the extension arms, the other is missing. There is a circular piercing through the boss, which, with the arm, is decorated with incised lines on both sides – possibly lattice decoration with a single groove, and possibly originally inlaid with niello (silver oxide).

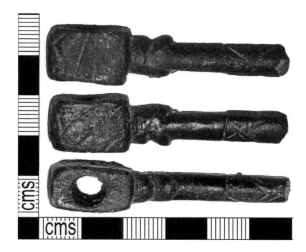

Similar bosses are on purse-bar frames, illustrated in figure 50 of the *London Museum Medieval Catalogue* (1967). This makes it part of Ward Perkins group A1-A3; it is probably A1.

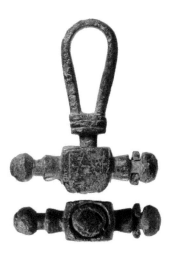

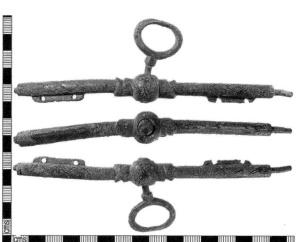

*Left*: An example of the frame of an A1 purse bar with the arms is SWYOR-04D512.

*Right*: Purse bars can have very long sidebars, such as this one from the Isle of Wight IOW-C8DDD8.

## 37. Brooch (LANCUM-36ADA9)
Medieval (*c.* 1000–1400 AD)
Discovered in 2013 in Salesbury.

Copper-alloy annular brooch of a type from the Finno-Ugrian areas of Russia, typical of areas such as Mordvinia and Tatarstan. The brooch has a wire loop, is sub-circular in section and is complete with pin and decorated triangular terminals. It has two integral rhomboidal-shaped plates; these are decorated with a series of longitudinal transverse lines, some of which are sub-divided, and incised longitudinal lines forming a border with reverse lines inside.

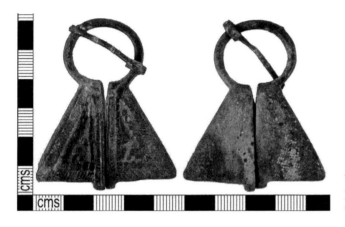

The ring is broken and the plates can be moved apart for ease of fastening.

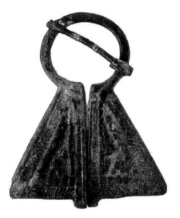

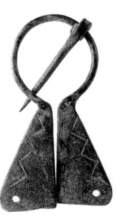

*Left*: The longitudinal lines follow the shape of the triangle, within which are a series of raised pellets.

*Right*: The only other brooch of this type on the database is SWYOR-64FC28. These are unusual finds in this country and may have both been lost in relatively modern times and then recovered.

74

## 38. Cooking Vessel (LVPL-73F494)
Medieval (*c.* 1200–1400 AD)
Discovered in 2003 in Carnforth.

This is a complete posnet, which is a cooking pot with a handle and three feet. There is only slight damage to the rim. The three legs are straight and taper slightly towards the feet. They are flat-sectioned with a strengthening mid-rib. There is no decoration or maker's mark, apart from a faint band around the circumference. G. Egan (1998) comments that 'commonly used cooking vessels include skillets, ewers, and cauldrons in use from *c.* 1100 until *c.* 1850 when cast-iron cooking vessels are used instead'.

*Right*: The straight handle tapers slightly and ends with a downward curve, supported at the body of the vessel by a brace.

*Below left*: Usually only the legs are found, such as WILT-33E99C.

*Below right*: Rim fragments are also commonly found. R. Butler, Christopher Payne and Naomi Green (2009) comment that 'rim fragments are likely to be from cauldrons or posnets', like this example from Huntingdon.

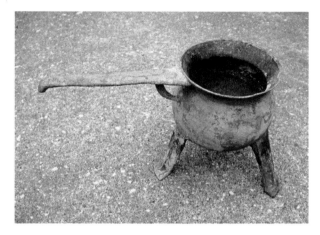

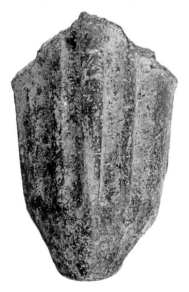

# Chapter 9
# Post-Medieval (AD 1540–1900)

The Post-Medieval period in Lancashire has a number of surviving substantial buildings.

Religious and secular objects are a feature of this period, such as a silver pyx used to protect and transport the Blessed Sacrament and a pilgrim's badge of St Ursula. Ursula was said to be a British princess who sailed with 11,000 virgin companions to marry a pagan prince in Brittany, before being slaughtered by Hun tribesmen in Cologne. She was later declared a saint, her cult spreading across Europe. Trade weights are a relatively common find but not the containers in which they were carried. Seal matrices can reveal the history of entire families.

Superstition was rife in this period and shoes placed within walls, over doorways or inside chimneys were commonly known as 'witch charms'. Toy petronels or cavalry pistols and cannons are able to inform knowledge of war games probably played by adults.

Silver thimbles were increasingly used by European nobility and gentry during the seventeenth century but surviving examples are rare even in the national collections of the British Museum and the Museum of London. In England, silver thimbles are documented as having been donated by women on the Parliamentary side to be melted down during the Civil War.

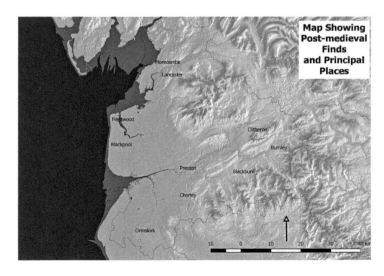

Map Showing Post-medieval Finds and Principal Places

Contains OS data Crown copyrights [and PAS database right] (2016).

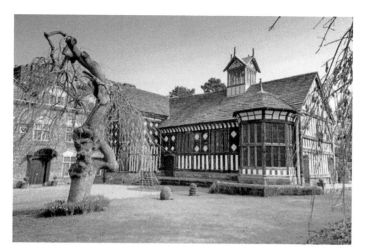

Rufford Old Hall, dating to 1540. (George Hopkins)

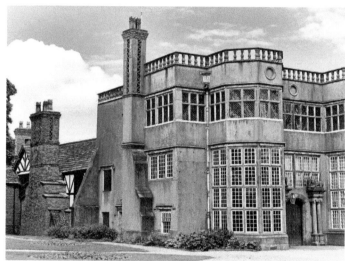

Astley Hall, dating to 1575. (Astley Hall)

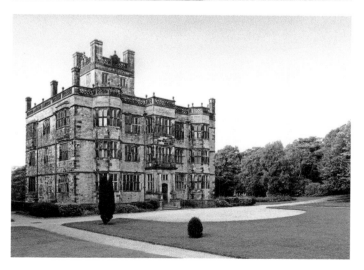

Gawthorpe Hall is an Elizabethan country house. (Valdas1964)

### 39. Pyx (LANCUM-6F19D5)
Post-Medieval (*c.* 1585–1647 AD)
Discovered in 2015 in Preston.

This silver pyx for dispensing communion wafers depicts Christ on the cross with '*INRI*' above, an acronym in Latin for *Iēsus Nazarēnus, Rēx Iūdaeōrum,* reading as 'Jesus the Nazarene, King of the Jews'. The two kneeling supplicants are probably Mary and the apostle John.

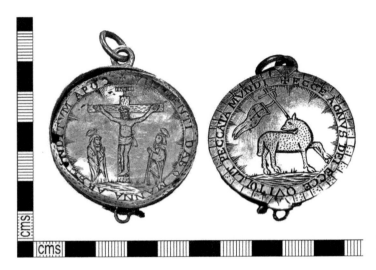

The lack of a hallmark/maker's mark is not surprising if it is English recusant silver relating to the secret services of persecuted Catholics.

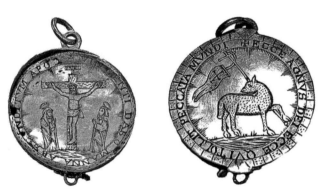

*Left*: The inscription reads, '*VINCENTI DABO EI MANNA ABSCONDITUM APOC*' ['APOC' for apocalypse, from *Revelations 2:17*], translated 'TO HIM WHO OVERCOMES I WILL GIVE HIDDEN MANNA ALLELUIA'.

*Right*: The reverse depicts a lamb with raised foreleg on a grassy knoll, looking back with a cross behind and pennant also depicting a cross. The inscription reads, '*ECCE-AGNVS-DEI-ECCE-QUI-TOLLIT-PECCATA-MVNDI*', which translates to, 'BEHOLD THE LAMB OF GOD BEHOLD YOU WHO TAKE AWAY THE SINS OF THE WORLD'.

## 40. Pilgrim's Badge (LANCUM-61F133)
Post-Medieval (*c.* 1585–1647 AD)
Discovered in 2011 in Preston.

This silver 'badge' is reminiscent of pilgrims' badges, popular from the fourteenth century until the Reformation, although most are made of lead alloy, not precious metal. James Robinson (British Museum) has suggested this 'badge' might be of St Ursula, due to its resemblance to the bust reliquary of a female saint, probably a companion of St Ursula, in the collections of the Metropolitan Museum of Art, New York.

They were sewn on to textile clothing. The low neckline of her dress reveals a cruciform pendant. On the reverse there are two stitching loops and a third loop is missing.

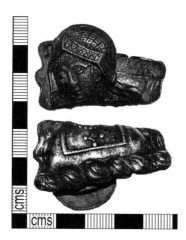 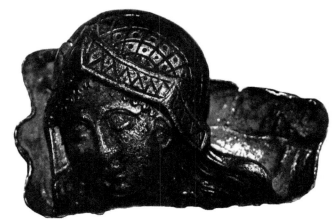

*Above left*: The badge may come from a Bruges workshop.

*Above right*: It depicts a female bust, in quarter profile, wearing early sixteenth-century dress, including a 'kennel-shaped' head-dress with hair loose beneath.

*Right*: A reconstruction joining the two halves.

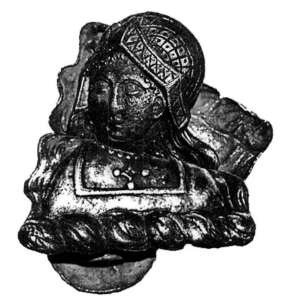

## 41. Box (LANCUM-6F0176)
Post-Medieval (*c.* 1400–1600 AD)
Discovered in 2013 in Croston.

This is a cast copper-alloy trade-weight holder. Trade weights themselves are a very common find but the containers that held them are very rare; for a complete one to be discovered is a very rare find indeed. The circular box's outwardly sloping sides have four ribs, evenly spaced, and two thicker hollow ribs for the hinge and latch. The interior and base are plain.

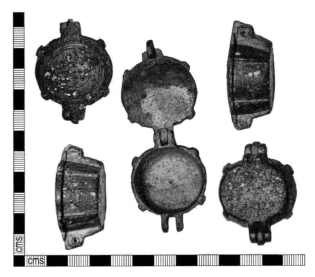

The box is for a set of small weights.

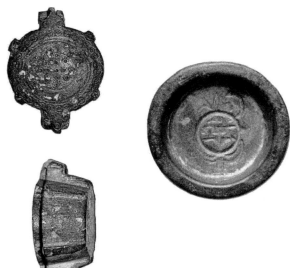

*Left*: The lid is decorated with annulets and concentric rings.

*Right*: WILT-7FE44C is a trade weight that would have been carried in a container.

This object is a silver seal that has a record of arms originally from Shropshire relating to the device inscribed on it.

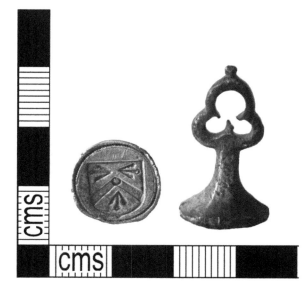

It is possible that it was deposited in the English Civil War 1642–1651 when men of Shropshire were fighting in Lancashire.

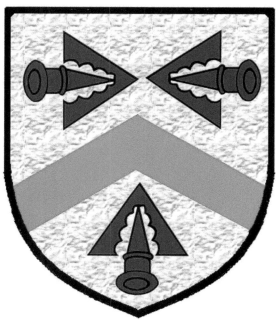

The arms are of the Kiffin/Kyffin family of Shropshire (the name was later Cuffin). The arms are, 'Argent, a chevron gules between three pheons. The two in chief lying fesswise point to point and that in base erect sable'.

This is a clog shoe discovered in a wall when a retaining wall dating to before 1704 AD was repaired.

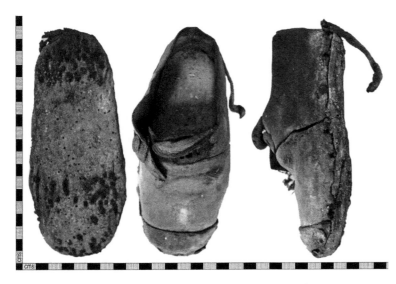

These objects were sometimes concealed as a protective device to ward off evil, a curse, illness or economic blight, a practice well known in Lancashire.

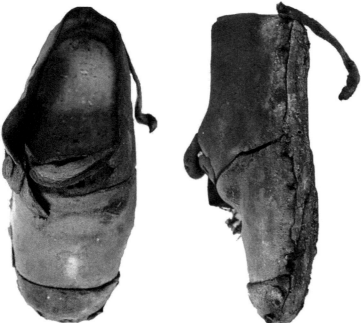

*Left*: The practice of placing a shoe within the structure of the walls was common in sixteenth- and seventeenth-century house building.

*Right*: This tradition relays that the shoe prevents the child being swapped for a fairy child, reflecting concerns over infants thought to be afflicted with unexplained diseases.

## 44. Thimble (LANCUM-18F154)
Post-Medieval (*c.* 1600–1700)
Discovered in 2013 in West Bradford.

An elongated silver thimble constructed from a sheet of silver, which has been soldered along the edges. The side seam is clearly visible, attached to a separate domed top and soldered to the almost straight sides. E. Holmes (1988: 3) writes that 'thimbles with hand-punched indentations often have a maker's mark struck where the spiral of indentations begins near the base and are usually imported mostly from Nuremberg'.

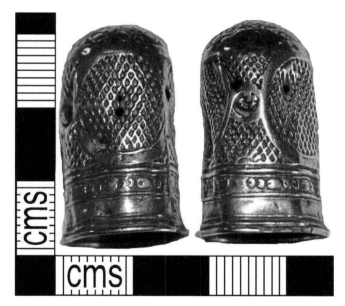

Thimbles with maker's marks normally date from 1520–1620.

*Left*: The body and most of the dome contain square indentations, giving a 'waffle' effect, with oval-shaped bands, possibly representing strap work, conjoined with smaller round bands.

*Right*: Below one of the round bands is a motif, probably a maker's mark; it is comprised of fronds that could be representing a stylised tree.

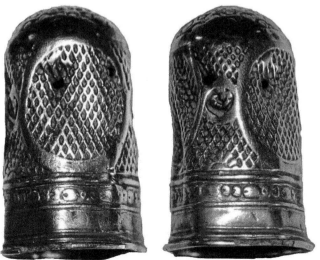

## 45. Whistle (LANCUM-A0E9F1)
Post-Medieval (c. 1500–1800)
Discovered in 2014 in Laneshaw Bridge.

A copper-alloy whistle, probably used for hawking. The whistle is circular in cross section. The mouth of the whistle is slightly tapered, and there is an oval half-moon-shaped opening just beneath the mouth.

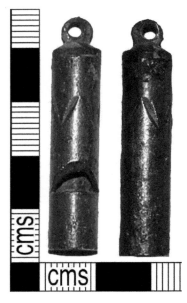

A suspension loop encloses the base of whistle. A series of engraved lines decorate the whistle with a zigzag pattern.

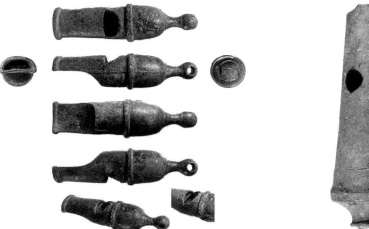

*Left*: Hawking whistles were also made out of tin (IOW-8AF4F2).

*Right*: Another metal utilised for whistles is lead, as in SUSS-296A24.

84

### 46. Toy (LANCUM-94B5B4)
Post-Medieval (*c.* 1872–1914)
Discovered in 2014 in West Bradford.

This petronel toy pistol is missing the firing mechanism (trigger, cock, springs, etc.) and the ends of the barrel and butt. Many different types of similar toy pistols have been recorded on the database, ranging in date from the sixteenth to the nineteenth century AD. This artefact resembles toy petronels or cavalry pistols reported from London described by H. Forsyth and G. Egan (2005). Guns of this type were based on the match-lock 'petronels' of the sixteenth and seventeenth centuries, and were fully working models.

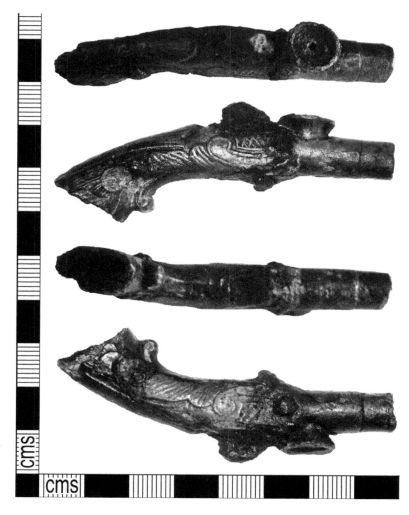

They were thought to be miniature versions used by gunsmiths to show prospective buyers the range of weapons, but they could also just be adult's toys.

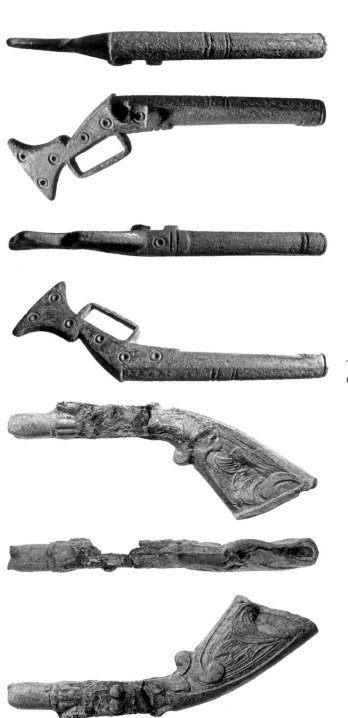

They were made in a range
of types, such as LIN-1F0453.

They were made in different
materials, like this one in lead
alloy, IOW-8C96AC.

These are two cast copper-alloy, anthropomorphic, non-identical head mounts from the east African seaboard.

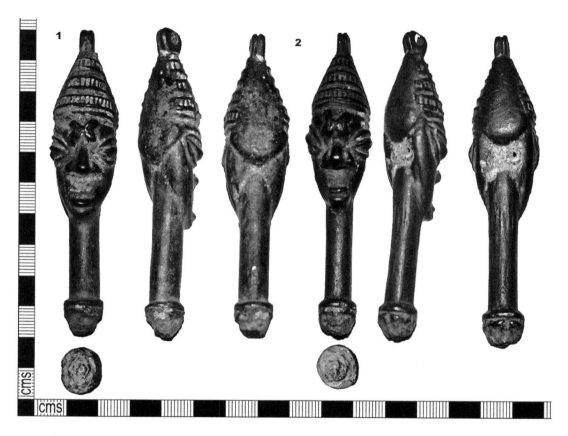

There are a number of finds discovered in Lancashire that are not from this country.

## 48. Token (LANCUM-AF0903)
Post-Medieval (*c.* 1850)
Discovered in 2011 in Fleetwood.

*Preston Guardian* newspaper token dating from 1872 when the office opened in Fishergate. The obverse inscription reads, 'THE MOST ELIGIBLE [] FOR ADVERTISEMENT IN NORTH & EAST LANCASHIRE', and the reverse, 'PRESTON GUARDIAN OFFICE IN FISHERGATE PRESTON'.

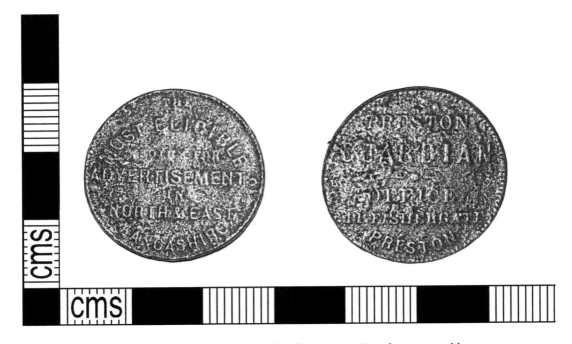

The *Preston Guardian* still exists, but is now called the *Farmers Guardian* – a weekly newspaper aimed at the British farming industry.

A copper-alloy shop token bearing the legends 'John Thornley Tea Merchant' around the outside and 'Established 1839' around the image of a teapot in the centre. The reverse reads 'The Golden Teapot is near the Castle Inn Market Place Preston 1850'. It shows evidence of re-use, having been pierced near the rim.

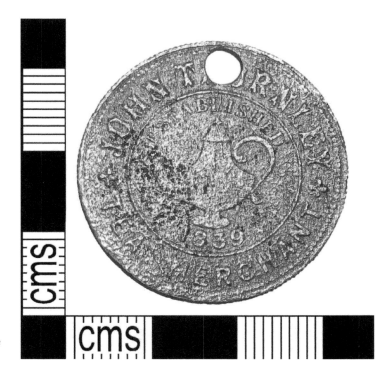

This is an early coin-like advertisement.

The object is part of a two-part mould, originally with two side valves of similar form. At the top of the object is a small channel for pouring in the molten metal. The barrel (cascable) would have had circumferential mouldings and a breech chamber, with a vent-hole sometimes referred to as a 'touch-hole' and a knop at the end of the breech chamber called a cascable button.

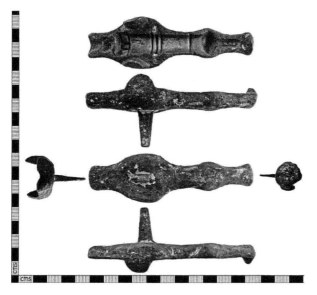

The cannons produced would have been oval in plan and lozenge shaped in cross-section.

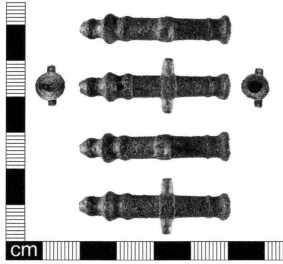

Cannons such as this one from Norfolk ESS-33EC9B would be cast in a mould.

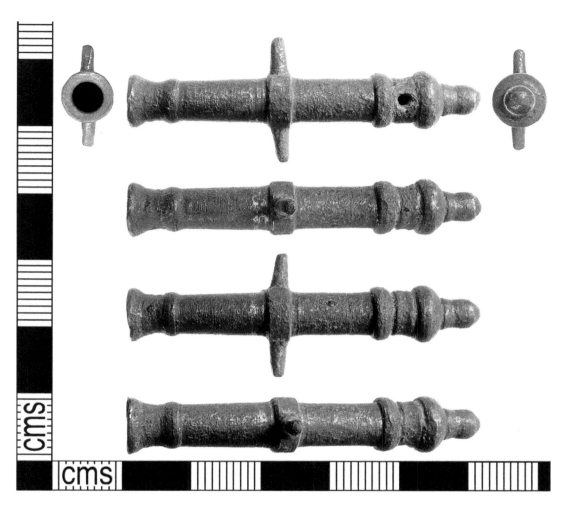

Cannons were working models such as this example from the Isle of Wight, IOW-C36D4C.

# Concluding thoughts from Dr Stephen Bull

The history we know is based largely on the written word. Much of it speaks of the formal business of the state or church, or the glory of the mighty. Yet this is only a part of the past: it says nothing of the societies of 'pre-history' that lacked written culture, nor does it include those from more recent times who could not read and write, or did not trouble to record their lives on tablet, paper or tape. Beyond this veil of silence stands only the artefactual evidence of archaeology.

Research and excavations tell us much of places and buildings, monuments and landscapes. However, formal academic archaeology is often targeted at known sites, or areas under threat. It also tends to deal primarily with the pictures our ancestors wanted to present of themselves: the rituals of death, the impressive edifices of religion and war, and the face they showed each other through domestic architecture and the planning of towns, villages and farms.

But what of the history we were never intended to know, the little things dropped at random in the course of daily business, the objects secreted, stolen, or scattered? For these are the artefacts with power to light up another world, the sometimes humble pieces that begin to tell us subtle stories about trade and wealth, the distribution of coins and personal adornment, and the passions and superstitions of the individual who made an offering, robbed his neighbour, lost her jewellery, or bartered at market and fair.

So it is that which the work of the national Portable Antiquities Scheme helps to illuminate – history that could so easily be lost again or never reach a wider audience. It also engages with the public, and encourages the responsible use of metal detectors and the reporting of finds for public and educational benefit. Since 1997, about a million objects have been recorded. This volume gives a fascinating glimpse at a small sample of the finds from one area, Lancashire, through the eyes of Finds Liaison Officer Stuart Noon. Some are truly magnificent and of major importance; others are just a footnote to the activity of an individual. All are part of the tapestry of life in Lancashire in the past.

Dr Stephen Bull
Curator Military History and Archaeology
Lancashire Museums

# Further Reading

Alcock, J., 'A Diana figurine from Bassingbourn, Cambs' in *Proceedings of the Cambridge Antiquarian Society. Vol LXXIX* (1990).

Allason-Jones, L. and Roger Miket, *The Catalogue of Small Finds from South Shields Roman Fort* (The Society of Antiquaries of Newcastle upon Tyne Gloucester: Alan Sutton: 1984).

Burgess, C. B., *Bronze Age Metalwork in Northern England c. 1000 to 700 BC* (Newcastle upon Tyne: Oriel Press, 1968).

Burgess, C. B., and Ian Colquhoun, *The Swords of Britain*. (Munchen: Prähistorische Bronzefunde, 1988).

Byard, A., *BERK-52E8C3 A BRONZE AGE CHISEL* (http://finds.org.uk/database/artefacts/record/id/488005 [Accessed: 8 May 2013 18:16:30], 2012).

Burgess, C. B., and Sabine Gerloff, *The Dirks and Rapiers of Great Britain and Ireland* (Munich: Prähistorische Bronzefunde, 1981).

Butler, R., Christopher Green, and Naomi Payne, *Cast Copper Alloy Cooking Vessels* (Finds Research Group Datasheet 41: Finds Research Group, 2009).

Cool, H. E. M., and Chris Philo (eds), *Roman Castleford: Excavations 1974–85. Volume 1. The Small Finds* (Wakefield: Yorkshire Archaeology 4, West Yorkshire Archaeology Service, 1998).

Cowell, R. W., 'The upper Palaeolithic and Mesolithic', in R. Newman (ed.) *The Archaeology of Lancashire; Present State and Future Priorities* (Lancaster: Lancaster University Archaeological Unit, 1996).

Crummy, N., *Colchester Archaeological Report 2: The Roman small finds from excavations in Colchester, 1971-9* (Colchester: Colchester Archaeological Trust Ltd, 1983).

Dunkin, J., *The History and Antiquities of Bicester, a Market Town in Oxfordshire: Comp. from Original Records ... and Containing Translations of the Principal Papers, Charters, &C. in the Kennett's Parochial Antiquities* (London: R. and A. Taylor, 1816).

Egan G., *The Medieval Household Daily Living c. 1150–c. 1450* (Museum of London, London: The Stationary Office Books, 1998).

Egan, G. and Frances Pritchard, *Dress Accessories, c. 1150–c. 1450 Medieval Finds from Excavations in London* (London: Stationery Office Books, 1991).

Egan, G. and Frances Pritchard, *Dress Accessories 1150–1450: Medieval Finds from Excavations in London* (4th edition) (London: The Stationary Office Books, 2002).

Ellis-Davidson, H.R., *The Sword in Anglo-Saxon* (England: Oxford, 1962).

Forsyth, H., and Geoff Egan, *Toys, Trifles and Trinkets: Base Metal Miniatures from London 1200 to 1800* (London: Unicorn Press Ltd, 2005).

Geake, H. (ed.), *Portable Antiquities Scheme* (Medieval Archaeology, 2002).

Gerloff, S., *The Early Bronze Age Daggers in Great Britain, and a Reconsideration of the Wessex Culture* (Munchen: C. H. Beck'sche Verlagsbuchandlung, 1975).

Hammond, B., *British Artefacts Volume 3 – Late Saxon, Late Viking & Norman* (Greenlight Publishing, Witham, 2013).

Hattatt, R., *Ancient and Romano-British brooches* (Sherborne: Dorset Publishing, 1982).

Hattatt, R., *A Visual Catalogue of Richard Hattatt's Ancient Brooches* (Oxford: Oxbow Books, 2000).

Hayward Trevarthen., C, *DOR-F18347 A BRONZE AGE CHISEL* (http://finds.org.uk/database/artefacts/record/id/493532 [Accessed: 8 May 2013 18:13:28], 2012).

Holmes, E., *Sewing Thimbles. Datasheet 9. Finds Research Group 700–1700 Datasheets 1-24. 1985-1998* (Reprographic Unit: University of Oxford, 1988).

Jackson, R., *Cosmetic Sets from Late Iron Age and Roman Britain, Britannia, Vol. 16* (London: Society for the Promotion of Roman Studies, 1985).

Jope, E. M., *Early Celtic Art in the British Isles Clarendon* (Oxford: Oxford University Press, 285, 2000).

MacGregor, M., *Early Celtic Art in North Britain: a Study of Decorative Metalwork from the Third Century B.C. to the Third Century AD (*Leicester: Leicester University Press, 1976).

Mackreth, D. F., *Roman Brooches* (Salisbury: Salisbury and South Wiltshire Museum, 1973).

May, J., *Dragonby: A Report on Excavations at an Iron Age and Romano-British Settlement in North Lincolnshire* (Oxford: Oxbow Books, 1996).

Oakeshott. R. E., *The Sword in the Age of Chivalry*, (London: Arms & Armour Press, 1981).

Oakeshott. R.E., *The Archaeology of Weapons: Arms and Armour from Prehistory to the Age of Chivalry* (New York: Dover Publications Inc, 1996).

Page, W., *Victoria County History Oxfordshire* (London: Archibald Constable & Co Ltd, 1907).

Petersen, J., *De Norske Vikingesverd. En typologisk-kronologisk studie over vikingetidens vaaben* (Kristiania: Videnskaps-Selskapets, 1919).

Saunders, P., (ed.) *Salisbury and Southern Wiltshire Museum Medieval Catalogue Part 4.* (Salisbury: Salisbury and Wiltshire Museum, 2001).

Snape, M. E., *Roman Brooches from North Britain: A classification and a catalogue of brooches from sites on the Stanegate* (Oxford: British Archaeological Reports, 1993).

Spencer, B., *Salisbury Museum Medieval Catalogue: Part 2, Pilgrim souvenirs and secular badges* (Salisbury: Salisbury and South Wiltshire, 1990).

Ward-Perkins, J.B., *The London Museum Medieval Catalogue* (London: HMSO, 1940).

Worrell, S., 'Enamelled vessels and related objects recorded to the Portable Antiquities Scheme' in D. Breeze and E. Kunzl, *First Souvenirs: Enamelled Vessels from Hadrian's Wall* (Carlisle: Cumberland and Westmorland Archaeological Society, 2012).

## The Portable Antiquities Scheme

The Portable Antiquities Scheme (PAS) was first established in 1997 as a pilot scheme following the introduction of the Treasure Act. Over the past eighteen years it has grown into a national project which employs over forty archaeologists (Finds Liaison Officers – FLOs) covering both England and Wales. Scotland and Northern Ireland have different laws governing the reporting of artefacts. The core role of the PAS is to record and identify archaeological objects found by the public. These finds fill the gap between known historical sites and act as a counterbalance to much of the work undertaken on other archaeological projects. FLOs also work closely with coroners helping to administer the Treasure Act (1996); this replaced the medieval law of Treasure Trove and gave museums the chance to acquire many important artefacts for the nation.

In the North West region PAS employs three Finds Liaison Officers covering the following counties: Cumbria, Lancashire, Cheshire, Greater Manchester and Merseyside. We all work in similar ways, meeting finders through recording days in museums and by visiting metal detecting clubs. Outreach days are held to promote the scheme as a research and education tool and talks are given to local groups and societies. Pas have recorded over a million objects and continues to record hundreds of finds every week thanks to the active participation and engagement with members of the public. Once recorded these finds don't lie dormant on the database (www.finds.org.uk/database) but are used in research by professional archaeologists, university students and school children to shape our knowledge of the past.

Working as an FLO to engage with the public and their finds in Lancashire means discovering something interesting and new every day, finding out more about the past and in some cases changing how we see the past. Through recording these finds we not only gather knowledge of the objects themselves but also of the landscape to which they belong. Anyone can discover an object, whether intentionally through metal detecting or accidentally while gardening. It is not only the diversity of the finds and the excitement of handling objects hundreds of years old which makes being an FLO great, but also the diversity of the finders allowing us to unravel the mysteries of the past.